HOW TO DRAW MANGA

Getting Started

Basic Tools, Tips and Techniques for Aspiring Artists

HOW TO DRAW MANGA: Getting Started
by K's Art

Copyright © 1997 K's Art
Copyright © 1997 Graphic-sha Publishing Co., Ltd.

First designed and published in 1997 by Graphic-sha Publishing Co., Ltd.
This English edition was published in 2000 by
Graphic-sha Publishing Co., Ltd.
Sansou Kudan Bldg. 4th Floor
1-14-17 Kudan-kita, Chiyoda-ku, Tokyo 102-0073, Japan

Executive Producer: Katsuya Yamakami
Production Manager: Hikaru Hayashi
Mechanical Design: Maguro
Production Assistants: Nobuko Yuuki, Tetsusaburo Takano
Japanese edition Editor: Motofumi Nakanishi (Graphic-sha Publishing Co., Ltd.)
English edition Editor: Glenn Kardy (Japanime Co., Ltd.)
English edition cover drawing: Ganma Suzuki
English edition cover and text layout: Shinichi Ishioka
English translation: Christian Storms
English translaion management: Língua fránca, Inc. (an3y-skmt@asahi-net.or.jp)
Foreign language edition project coordinator: Kumiko Sakamoto (Graphic-sha Publishing Co., Ltd.)

Distributed by
Japanime Co., Ltd.
2-8-102 Naka-cho, Kawaguchi-shi,
Saitama 332-0022, Japan
Phone/Fax: +81-(0)48-259-3444
E-mail: sales@japanime.com
http://www.japanime.com

First printing: October 2000
Second printing: August 2001
Third printing: November 2001
Fourth printing: March 2002
Fifth printing: August 2002

ISBN: 4-921205-00-0
Printed and bound in China by Everbest Printing Co., Ltd.

Table of Contents

Chapter 1
– The Basics –
Pens, Ink and Paper

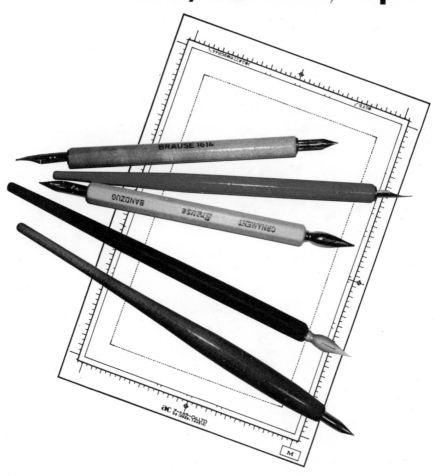

Topic 1
The Bare Essentials

Scrap paper, a mechanical pencil and an eraser.

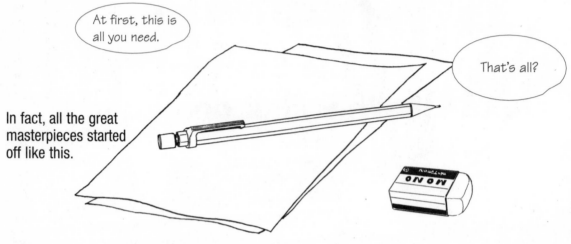

In fact, all the great masterpieces started off like this.

In the beginning, all you need are some basic writing implements.

Topic 2
Tools of the Trade

Manga begin as simple drawings that require nothing more than a pen and ink. Buy items such as rulers, feather dusters and white-out as you find you need them.

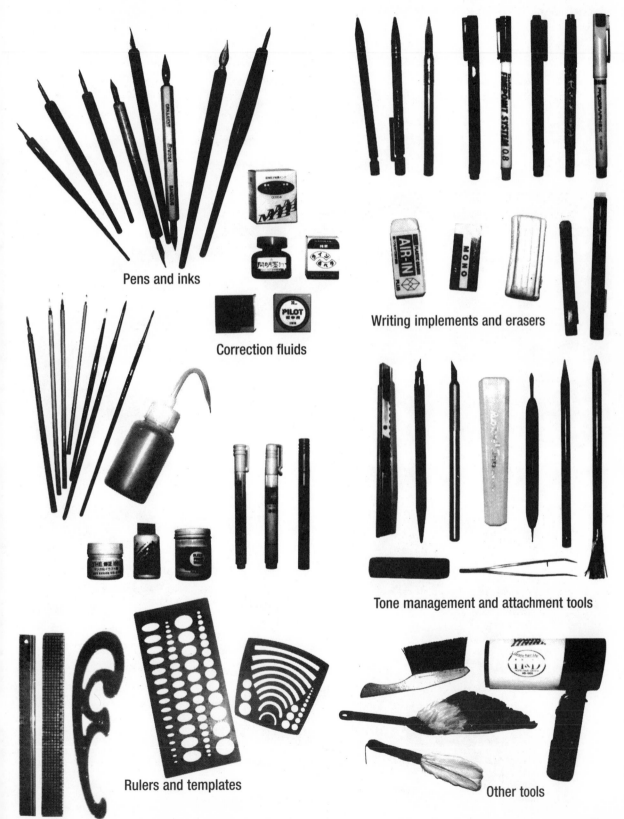

Pens and inks

Correction fluids

Writing implements and erasers

Tone management and attachment tools

Rulers and templates

Other tools

Pen tips and bodies are sold separately. Replace old, worn tips and use new ones. Be sure to have some spares on hand.

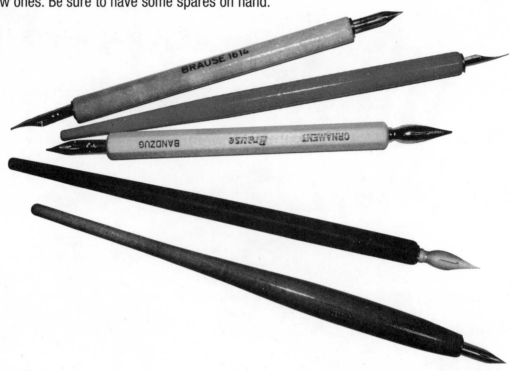

Insert the pen tip and draw away!

insert like this

pen tip

pen body

Topic 4
Types of Pen Bodies

There are a variety of pen bodies. Choose one that is comfortable to use.

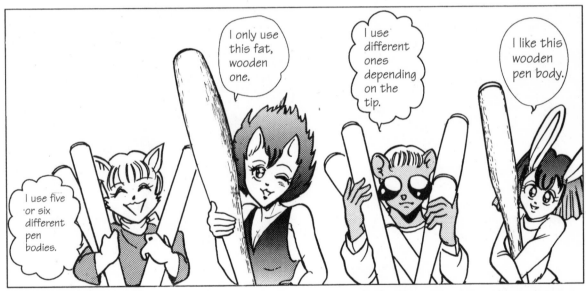

Some people feel that pens with long bodies are too heavy and cumbersome. If you feel this way, cut off the end of the pen.

The end has been cut off.

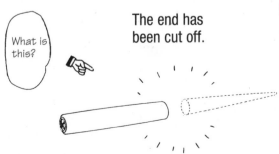

Shortened pen

It's lighter and easy to draw with.

Pen tips are manufactured by such companies as Zebra and Tachikawa, among others. There are four basic types of tips.

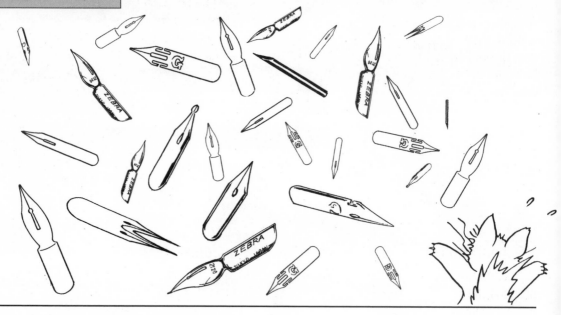

G-Pens

Tachikawa Nikko Zebra

Round Pens
('marupen' in Japanese)

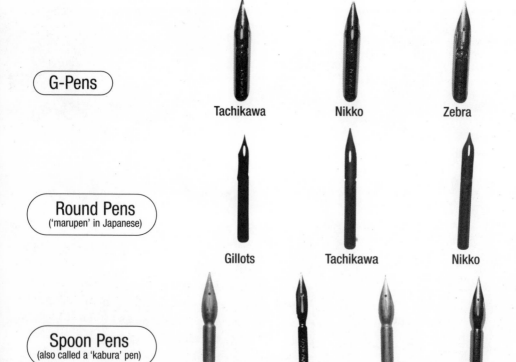

Gillots Tachikawa Nikko Zebra

Spoon Pens
(also called a 'kabura' pen)

Tachikawa Tachikawa Nikko Zebra Zebra
(Aluminum) (Chrome) (Aluminum) (Chrome)

- G-pens and round pens have a wide following.
- Spoons pens (kabura pens) are less popular.
- School pens are said to be for people with a heavy drawing hand.

School Pens

Tachikawa

Round Pens

While the feel when drawing with round pens is hard, they give distinction between thick and thin lines.

G-Pens

G-pens yield soft and flexible lines. Thick lines can also be drawn with these kinds of pens.

School Pens

School pens produce the hardest lines of all and are ideal for extra-fine work.

Spoon Pens

Spoon pens yield smooth, fluent and somewhat soft lines.

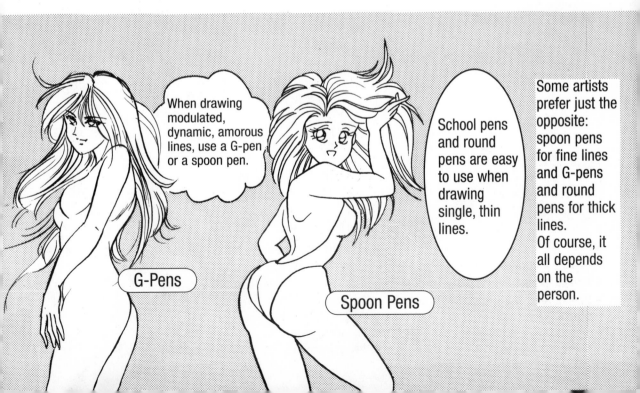

When drawing modulated, dynamic, amorous lines, use a G-pen or a spoon pen.

G-Pens

School pens and round pens are easy to use when drawing single, thin lines.

Spoon Pens

Some artists prefer just the opposite: spoon pens for fine lines and G-pens and round pens for thick lines.
Of course, it all depends on the person.

Which pen tip should you choose? It all depends on whom you ask and, of course, what you need the pen to do.

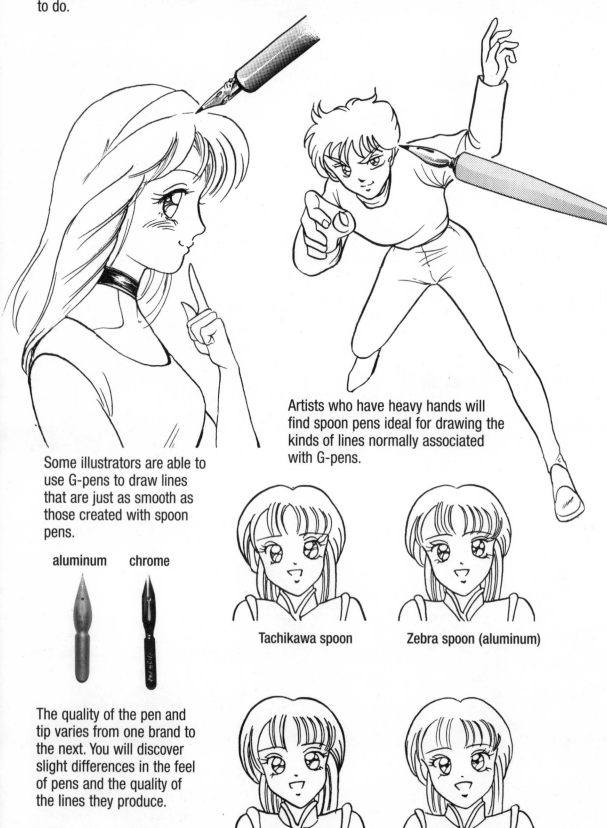

Some illustrators are able to use G-pens to draw lines that are just as smooth as those created with spoon pens.

aluminum chrome

The quality of the pen and tip varies from one brand to the next. You will discover slight differences in the feel of pens and the quality of the lines they produce.

Artists who have heavy hands will find spoon pens ideal for drawing the kinds of lines normally associated with G-pens.

Tachikawa spoon Zebra spoon (aluminum)

Nikkoo spoon Zebra spoon (chrome)

Topic 6
Proper Use of Different Kinds of Pen Tips

Since well-defined illustrations are fundamental to manga, characters are drawn with thick lines and backgrounds with thin lines.

Bad example: The outlines of the character are thin and the background lines are thick.

Bad example: The outlines of the character and the background have the same thickness.

Good example: The outlines of the character are thin but the lines of the background are even thinner.

Good example: The outlines of the character are thick and the lines of the background are thin.

Experienced artists use a variety of pen tips.

Thick, modulated lines can be easily drawn with G-pens and round pens. Thick lines cannot be produced with spoon pens or school pens without applying a lot of force, and are therefore best suited for uniform lines.

With the same round pen, there is a noticeable difference in the lines drawn with new and used pen tips. Some people like to have several pens on hand and divide their usage.

I use a round pen for everything.

Round pen bodies

Not all pen tips fit all pen bodies.
Some brand-name pen bodies can only use tips produced by the same manufacturer. Before buying a round pen, make sure the tip fits the body.

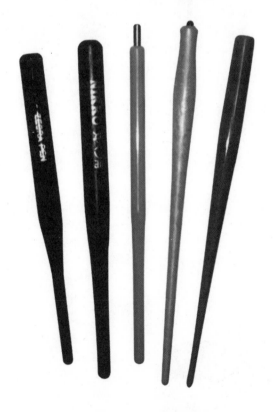

various round pen bodies

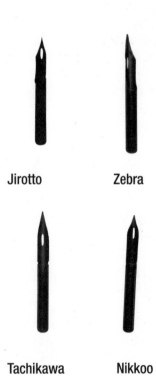

Jirotto Zebra

Tachikawa Nikkoo

Topic 7
New and Used Pen Tips: Choosing One That's Right

As the tip of the pen becomes worn with use, the thickness of the lines and the feel of the pen will change. The key is to know when to change tips.

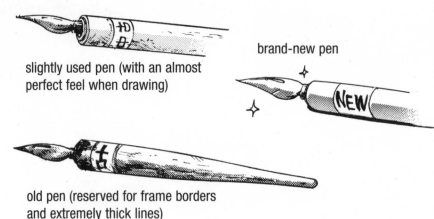

slightly used pen (with an almost perfect feel when drawing)

brand-new pen

old pen (reserved for frame borders and extremely thick lines)

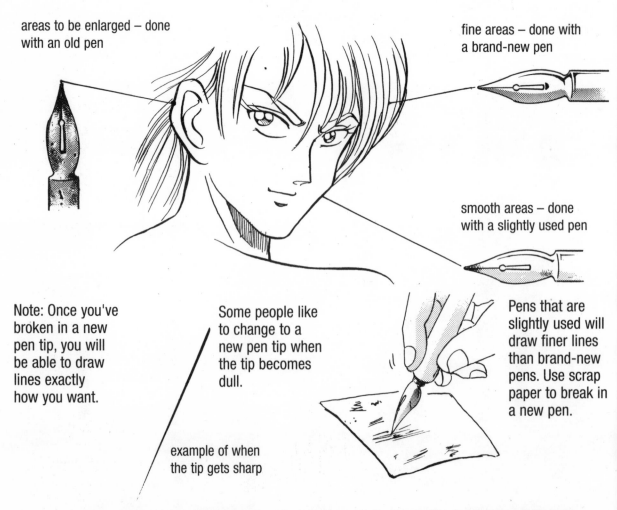

areas to be enlarged – done with an old pen

fine areas – done with a brand-new pen

smooth areas – done with a slightly used pen

Note: Once you've broken in a new pen tip, you will be able to draw lines exactly how you want.

Some people like to change to a new pen tip when the tip becomes dull.

example of when the tip gets sharp

Pens that are slightly used will draw finer lines than brand-new pens. Use scrap paper to break in a new pen.

- pen tip sharpness – A pen whose tip is sharp will produce lines that end in a fine point. Round pens are said to be the best for drawing the sharpest lines.
- When the pen becomes easy to draw with, it can also mean that the pen tip has been crushed and cannot be used properly.

thin lines – round pen

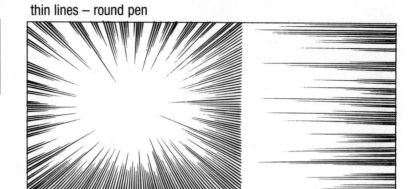

Pens and Their Respective Effect Lines

Round pens and school pens are best for uniform or thin lines. Spoon pens are good for sharp lines, and g-pens are best for strong lines.

thin lines – school pen

sharp lines – spoon pen

strong lines – G-pen

Topic 9
Reasons to Use Ink Pens

While it doesn't matter what you use to draw manga, keep in mind that drawings done with ballpoint pens and pencils do not show up well when printed. Since ballpoint pens in particular yield thin, monotonic lines and tend to leave rub marks, they are hardly ever used.

pencil

ballpoint pen

Felt-tip pens are used for emphasizing outlines and coloring in with black. Since they sometimes run and cannot be used for drawing sharp, fine lines, their use should be reserved for bringing out special qualities in drawings.

running ink

Ink pen felt-tip pen

emphasis
(extremely thick lines)

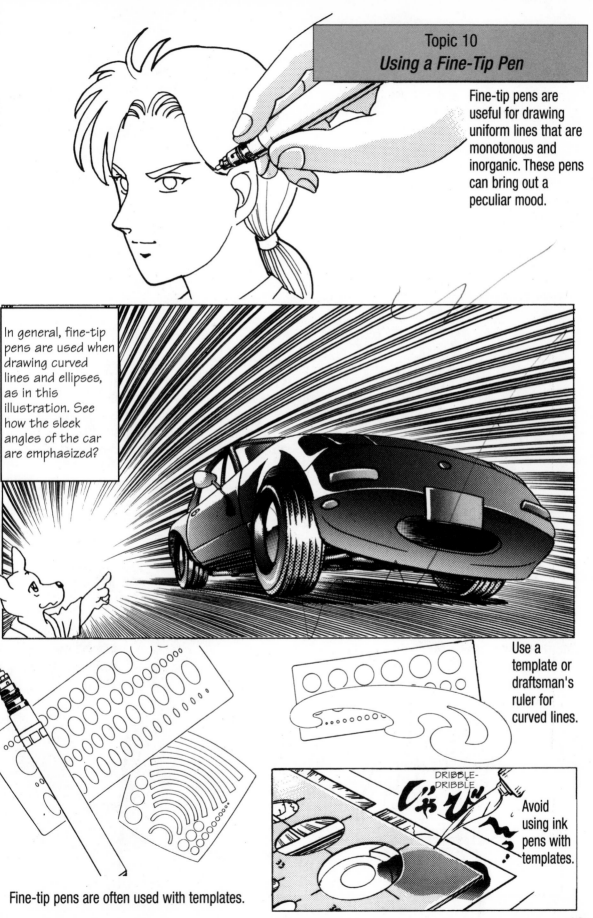

Topic 10
Using a Fine-Tip Pen

Fine-tip pens are useful for drawing uniform lines that are monotonous and inorganic. These pens can bring out a peculiar mood.

In general, fine-tip pens are used when drawing curved lines and ellipses, as in this illustration. See how the sleek angles of the car are emphasized?

Use a template or draftsman's ruler for curved lines.

Fine-tip pens are often used with templates.

DRIBBLE-DRIBBLE

Avoid using ink pens with templates.

19

What are the differences between normal ink, document ink and drawing ink?

Here are two illustrations done in ink.

A Few Words About Ink:
There are two kinds of ink: waterproof and water-soluble. As both are chemical products, a chemical reaction occurs when they are mixed together, and over time the colors will fade. You may be tempted to add or mix inks when supplies are running low. However, it's best not to mix inks at all, even if they are the same type and brand.

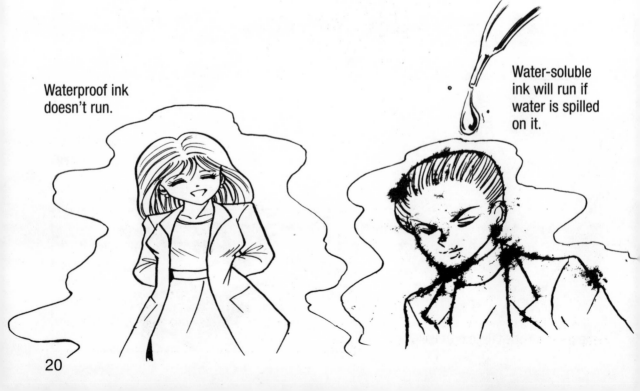

Waterproof ink doesn't run.

Water-soluble ink will run if water is spilled on it.

Normal black ink, drawing ink and India ink are water-soluble.

Water-soluble means something that dissolves in or runs with water.

Even if you spill water on drawings done with document ink, they will be fine.

This kind of ink is waterproof.

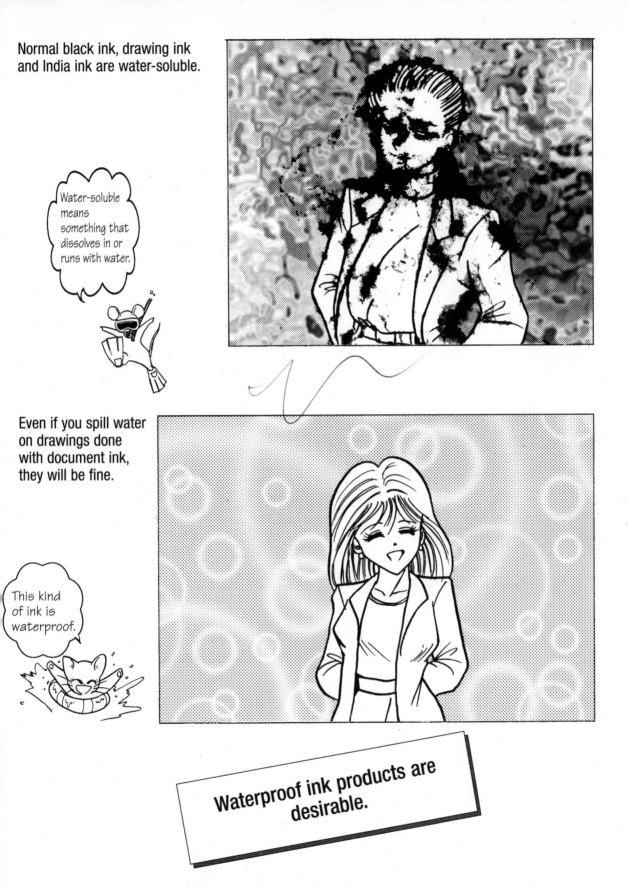

Waterproof ink products are desirable.

• Most experienced manga artists don't like black document ink, as it tends to be a bit on the thin side. They prefer to use drawing ink instead.

While high-quality inks are easy to draw with, all inks look the same when printed.

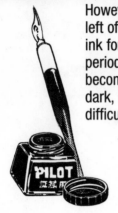

However, if the top is left off the bottle of ink for an extended period, the ink will become old and too dark, making it difficult to use.

For example, here is a brand-new pen with old ink on the tip.

SCREECH-SCREECH

キキ

The ink doesn't come out.

When a pen writes like this the ink is too old. Switch to new ink and you'll find it much easier to draw.

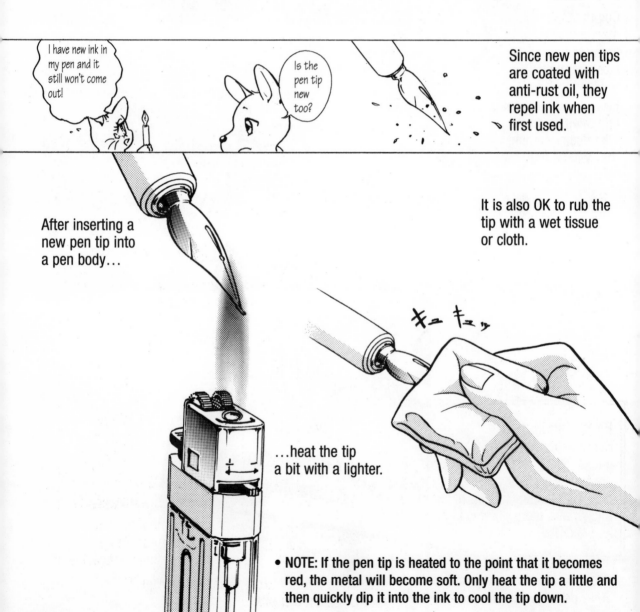

I have new ink in my pen and it still won't come out!

Is the pen tip new too?

Since new pen tips are coated with anti-rust oil, they repel ink when first used.

After inserting a new pen tip into a pen body…

…heat the tip a bit with a lighter.

It is also OK to rub the tip with a wet tissue or cloth.

キュ キュッ

- **NOTE:** If the pen tip is heated to the point that it becomes red, the metal will become soft. Only heat the tip a little and then quickly dip it into the ink to cool the tip down.

There are basically two sizes of manga paper: B4 and A4.
B4 size is roughly 1.25 times larger than the average manga magazine.

B5
The size of the average manga magazine

A4
Use this size when drawing for 'individual press' manga.

B4
Use this size when drawing for the majority of manga magazines.

Commercial manga magazines are drawn in B4 size and then reduced to 82% and made into manga magazines.

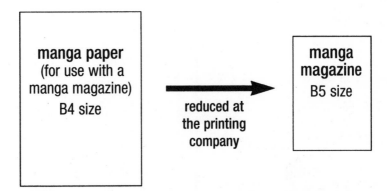

manga paper
(for use with a manga magazine)
B4 size

reduced at the printing company

manga magazine
B5 size

- While B4 paper is used, the drawing does not use up the entire page. Actually, the drawing area is fixed to about A4 size.
- NOTE: If B4 paper is reduced, it will not be B5 size (magazine size). The fixed A4 size drawing area when reduced will be B5 size.

Paper Quality:
Kento paper, art paper, and high-quality 90-kg and 135-kg paper are the types most often used in drawing manga. (135-kg paper is thicker and more durable than 90-kg paper.)

original size

82% size

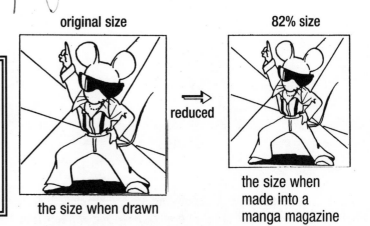

reduced

the size when drawn

the size when made into a manga magazine

The lines look sharper and more beautiful when reduced a bit!

The drawing area (frame) for manga pages is fixed. Manga paper sold commercially has the frame lines printed on the page.

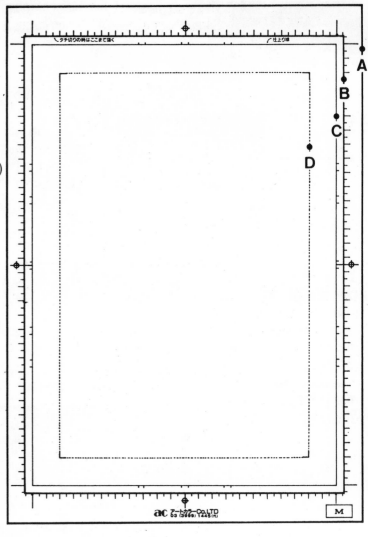

A: Paper Size
 B4 = 257mm × 364mm (10.1in. × 14.3in.)
 A4 = 210mm × 297mm (8.3in. × 11.7in.)
B: Draw to here for tachikiri (see next page).
C: Outer Frame – extend
 finishing touches to here
 B4 = 220mm × 310mm (8.7in. × 12.2in.)
 A4 = 182mm × 257mm (7.2in. × 10.1in.)
D: Inner Frame – the standard frame for
 dividing frames
 B4 = 180mm × 270 mm (7.0in. × 10.6in.)
 A4 = 150mm × 220mm (8.9in. × 8.7in.)

Since blue pencil lines don't show up in the printing, some people like to do outlines with them.

There are also special blue pencils that can be erased.

BLUE

The frame lines and guidelines are done in blue because this color does not show up when printed.

• NOTE: Lines drawn in blue pencil that are too strong will show when printed. Yellow lines will not show up at all. Red lines, however, will turn black when printed.

Tachikiri Lines

An illustration drawn to the edge of the paper is called 'tachikiri' in Japanese.

the edge of the paper

Extend the drawing a few centimeters beyond the normal frame to create tachikiri drawings. Manga paper has tachikiri guidelines indicating how far to extend the drawing.

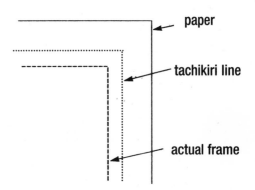

paper

tachikiri line

actual frame

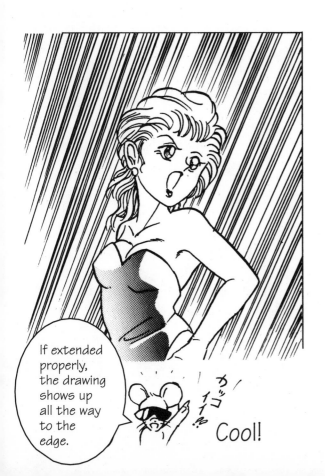

If extended properly, the drawing shows up all the way to the edge.

Cool!

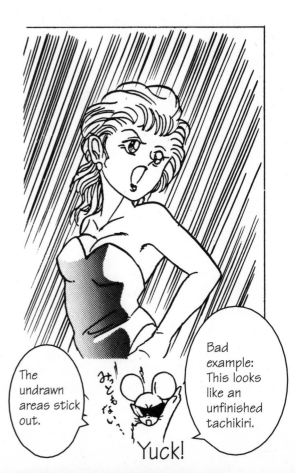

The undrawn areas stick out.

Bad example: This looks like an unfinished tachikiri.

Yuck!

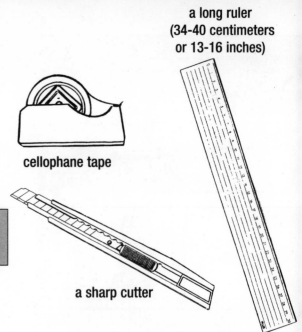

a long ruler
(34-40 centimeters
or 13-16 inches)

cellophane tape

a sharp cutter

Items to prepare

Topic 14
Creating Spreadsheets (two-page frames)

Join two pages to create a spreadsheet.

1 Gather two pages of manga paper.

2 Mark the side of the page that will be attached to the other page. (Make this mark along the frame border, not the tachikiri border.) Do this for both pages.

Then remove the marked area of each page using a ruler and cutter.

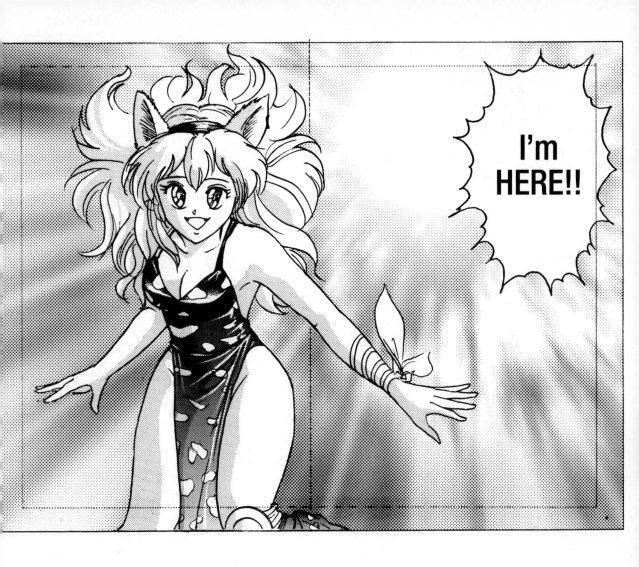

3 Line the two pages up perfectly.

Temporarily attach masking tape to the front side to help line up the pages.

4 Attach cellophane tape firmly along the back side.

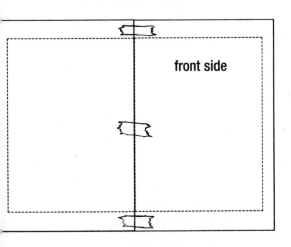

front side

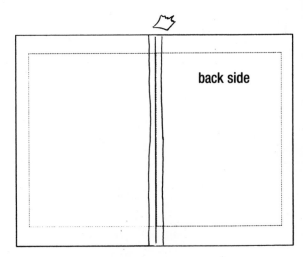

back side

Topic 15
Preventing Blotting When Inking
Why Ink Runs and What Paper to Use

Most outlines are drawn in pencil, which is easy to erase. If used too often or too heavily, though, erasers can damage paper. When the drawing is finished in ink, it is these damaged areas that cause the ink to run.

Kento paper, high-quality paper and manga paper are durable enough to handle a little erasing.

Countermeasure 1

Go easy on the paper.

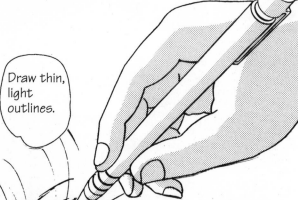

Draw thin, light outlines.

Countermeasure 2

Keep the page dry. Rest your hands atop a piece of clean scrap paper to avoid staining the manga page with oil or sweat. Avoid touching the page as much as possible.

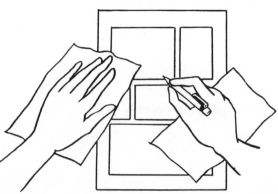

- Oil and sweat from fingers and hands cause ink to run.
- Just one drop of water on a page can cause ink to run, even after the water has seemingly dried.
- Some artists like to rest their hands on paper towels when drawing.

When old ink is used, it can lead to running. Use new ink to avoid this problem.

I use commercially produced manga paper.

It is possible to use an eraser without damaging the paper.

Commercially Sold Manga Paper:

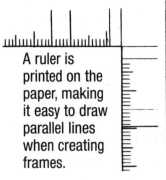

A ruler is printed on the paper, making it easy to draw parallel lines when creating frames.

Kento Paper:

Super for drawing smooth lines when using ink. For artists who like to use a lot of odd-shaped frames, pages without ruled borders allow a greater amount of freedom.

I like to use Kento paper.

The thickness makes it feel like the pages of a real manga magazine.

- Some art stores also sell thin Kento paper.

Art Paper:

Pencils such as soft 2B and 6B can be used with art paper.

I prefer art paper!

While it does nap up when a normal eraser is used, when inking it has a soft feel not found in any other paper.

Of course, an art eraser (kneaded eraser) should be used.

29

Topic 16
Making Corrections

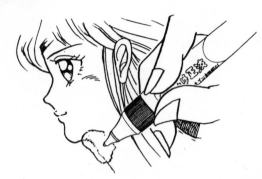

White-out is used for corrections. Oil-based white-out is fast-drying and effective. What's more, it is easy to use pens and fine-tip pens on top of the erased area.

before corrections

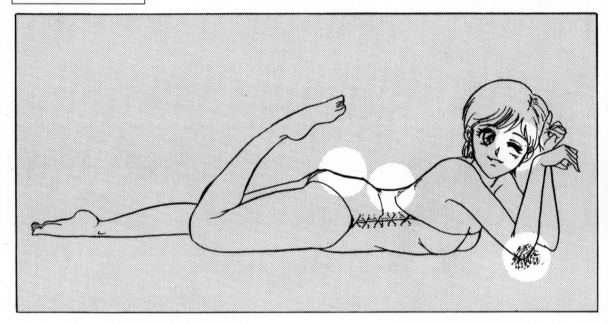

A fingerprint on the elbow was erased.

The wink looked different from what the artist had intended, so it was erased.

Liquid Paper™
correction fluid

white-out pens

after corrections

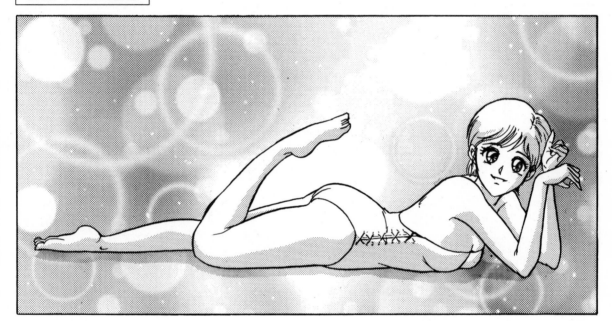

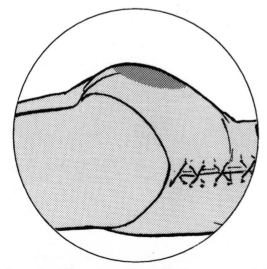

A crooked line along the buttocks was erased
and a curvier line was drawn.

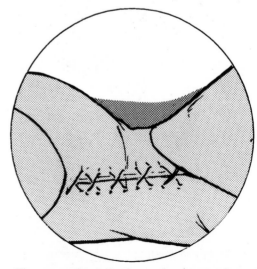

The area along the lower back was drawn too
wide, so it was corrected and redrawn.

various kinds of white-out

Most corrective liquids, commonly called white-out, are diluted with water before use. However, when correcting drawings done with water-soluble ink, don't add water to the corrective liquid.

correction liquid used solely for manga

Dr. Martin's Bleed Proof White™

Misnon™

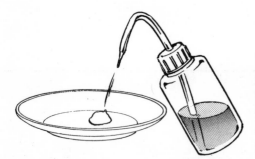

The greatest merit of white-out is that unlike with oil-based products, a brush can be used to correct detailed areas.

• Oil-based correction liquid is diluted with a special solution; however, ordinary brushes cannot be used with this.

correcting detailed areas

By using a fine brush, delicate operations can be performed!

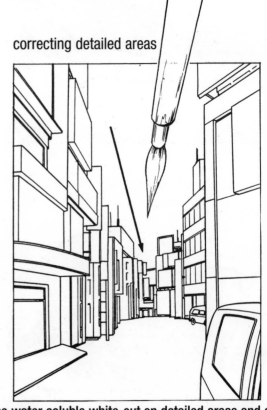

• One way to divide the usage of corrective liquids is to use water-soluble white-out on detailed areas and oil-based white-out on areas that you want to redraw. Some people only use water-based white-out for corrections. The use is a matter of taste as there are some differences in the ease of making corrections and applying finishing touches.

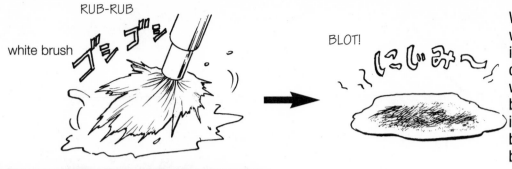

RUB-RUB

white brush

BLOT!

When using white-out, the ink in the corrected area will run and blot if the area is rubbed briskly with a brush.

How to Use Water-Based White-out

When using a brush, the trick is to cover the area with one stroke.

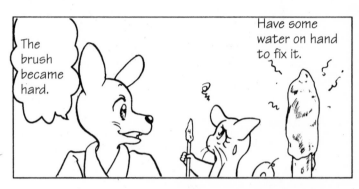

The brush became hard.

Have some water on hand to fix it.

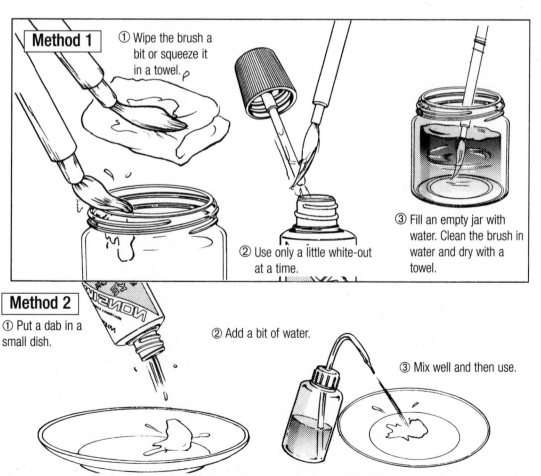

Method 1

① Wipe the brush a bit or squeeze it in a towel.

② Use only a little white-out at a time.

③ Fill an empty jar with water. Clean the brush in water and dry with a towel.

Method 2

① Put a dab in a small dish.

② Add a bit of water.

③ Mix well and then use.

I Spilled the Bottle!

1 The drawing will look like this if the white-out is immediately wiped away.

2 Once the white-out is completely dry, hold a cutter like this.

3 Scrape off the dried white-out with the back end of a cutter.

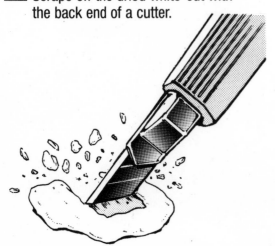

The white-out was removed successfully!

• With this technique, the trick is to dry the white-out quickly. When necessity arises, some pros use a hair dryer to dry the white-out.

Chapter 2
So You Wanna Draw Characters?

I want
draw
like
this!

SCRIBBLE
SCRIBBLE

But my drawing doesn't look
like the same...

Maybe if I add
ink it will look
better.

Now it's further off
than before!

Topic 18
How to Improve Your Characters

Draw because you like it. Never forget the pleasure of creating and drawing. The essence of improving your manga is to have fun doing it.

The only way to improve is to use your eyes.

Get to the bottom of what and why things don't look right and fix them.

It's hard to admit your own mistakes.

But you won't be able to improve as an artist unless you can confront and overcome your weaknesses.

Topic 19
Methods to Discover Differences in Drawings

It is easy to become attached to your drawings while having fun, which makes it difficult to view them objectively. But what are the differences? Use a ruler at times like this.

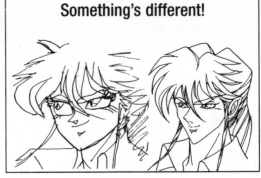

Something's different!

For example, by measuring the size of the eye, the height and width of the original can be determined.

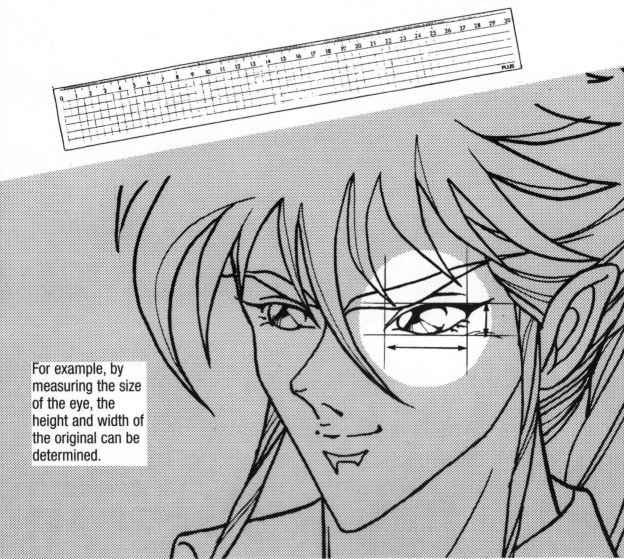

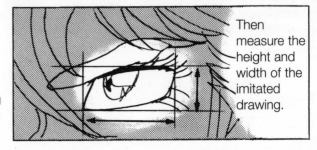

Then measure the height and width of the imitated drawing.

• The ruler analysis method not only works with faces but with full body drawings too.

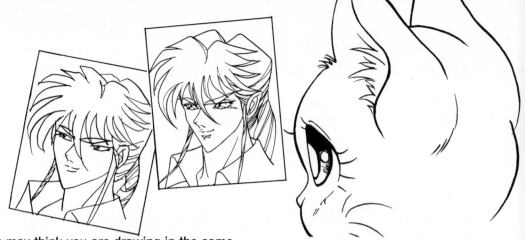

Even though you may think you are drawing in the same manner, the end result has some major differences.

original drawing

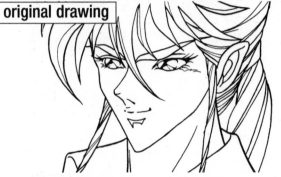

imitated drawing

The eyelashes in the original drawing sharply come to a point.

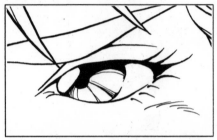

Those in the imitated drawing don't come to a point.

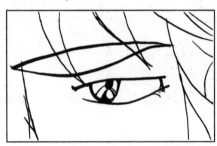

Fix the eyelashes in the following manner:

the hairline is thick

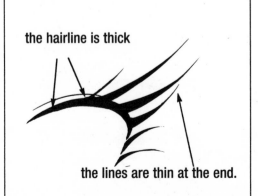

the lines are thin at the end.

All the lines are thin.

Oh no!

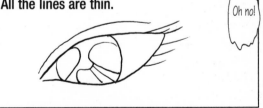

This time the eyelashes are too long.

I wanna draw something like this but...

What do you want to draw?

A cool hero saving a heroine.

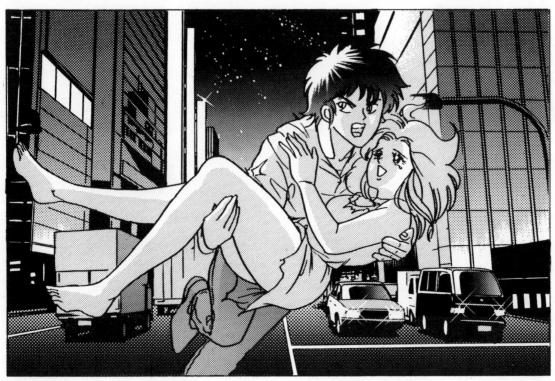

When you don't know how to draw something, find a picture book or photograph that resembles the image in your head and use that for reference.

Reference materials or models are a big part of drawing.

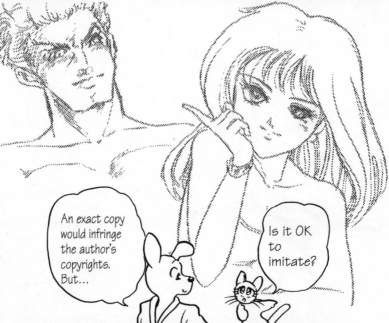

An exact copy would infringe the author's copyrights. But...

Is it OK to imitate?

• Hardly anyone can draw a picture without using something as a reference. The same goes for manga. Even the pros study other artists' works and then draw their own.

By tracing various parts, you will understand what to draw and how to draw it.

Consider how and why the lines of the hands, feet and other parts of the body were drawn in the original, but avoid the temptation to simply copy them.

By getting this experience under your belt, you will soon be drawing bodies with a high level of proficiency.

model picture

I finished but...

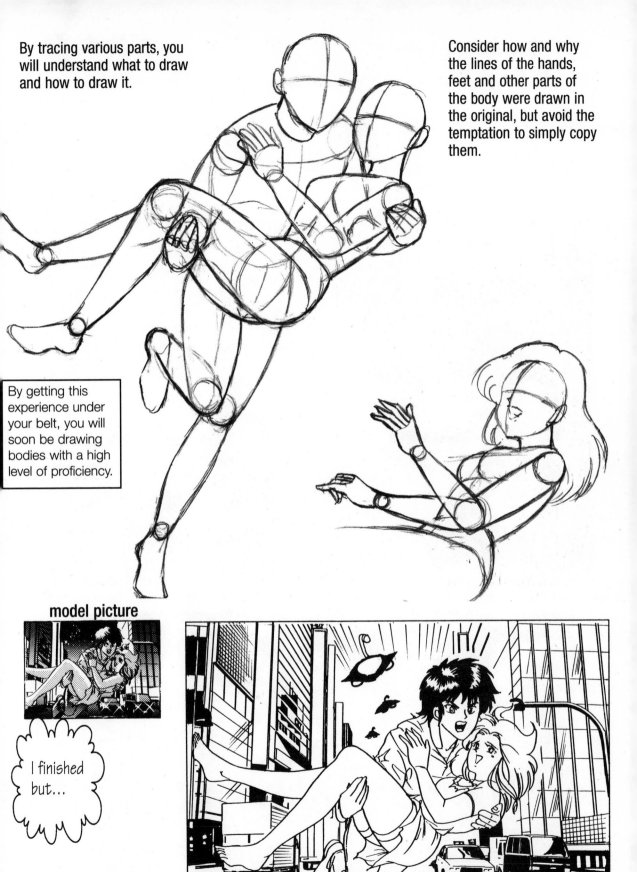

Bad example: The new illustration is almost the same as the original.

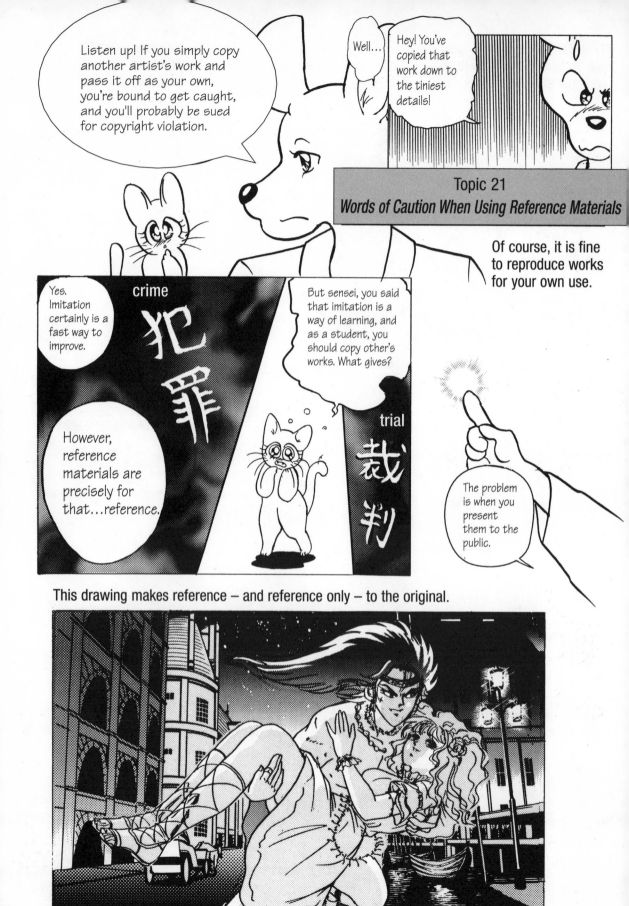

Topic 22
Using a Mirror to Study

Some people would rather die than imitate others' works. So they use other methods for developing their ideas.

For example, they research facial expressions by making faces in a mirror.

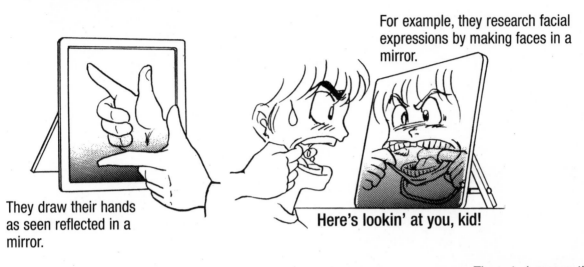

They draw their hands as seen reflected in a mirror.

Here's lookin' at you, kid!

They study poses they want to draw in front of a full-length mirror.

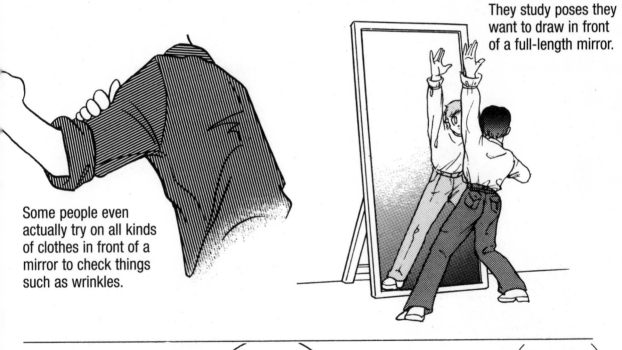

Some people even actually try on all kinds of clothes in front of a mirror to check things such as wrinkles.

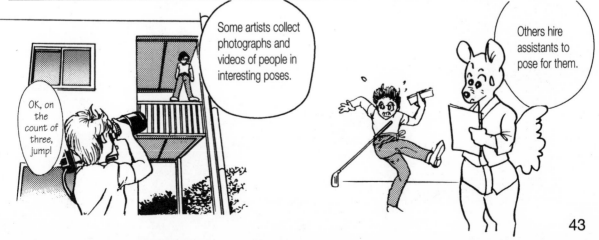

Some artists collect photographs and videos of people in interesting poses.

OK, on the count of three, jump!

Others hire assistants to pose for them.

43

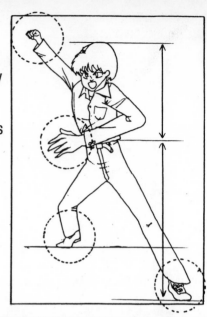

In manga the essence of the drawing ultimately comes down to balance. The source of coolness or beauty in a drawing can be found in the composition, sketching, modulation of black-and-white and the like.

Topic 23
How to Achieve Balance

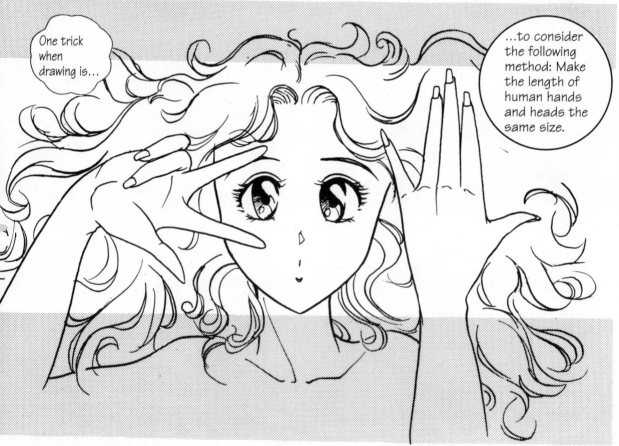

One trick when drawing is…

…to consider the following method: Make the length of human hands and heads the same size.

Small hands on female characters look cute.

Large hands on male characters look masculine.

44

A human figure can be viewed as a collection of parts.

head

body

leg

arm

hand

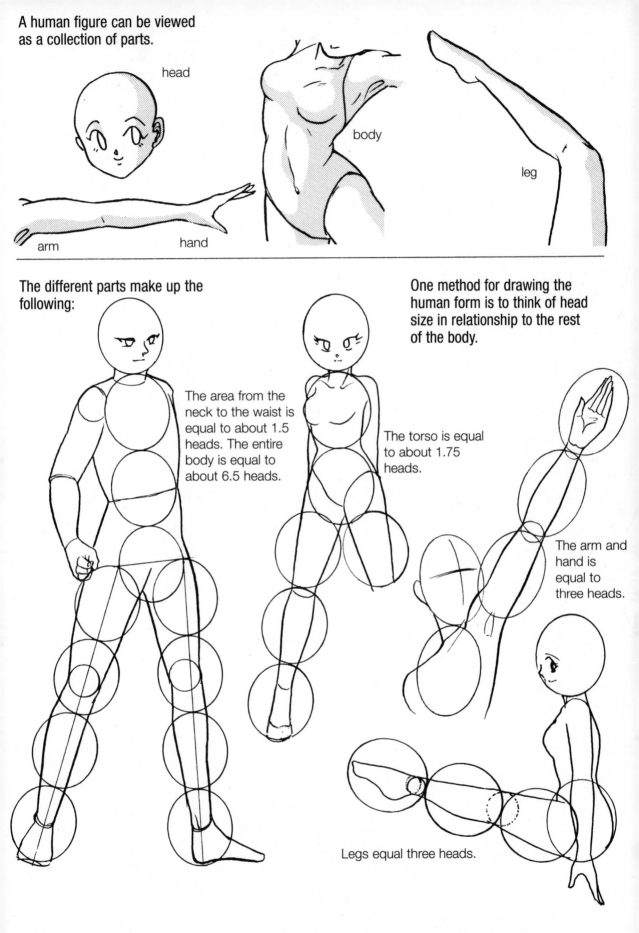

The different parts make up the following:

The area from the neck to the waist is equal to about 1.5 heads. The entire body is equal to about 6.5 heads.

One method for drawing the human form is to think of head size in relationship to the rest of the body.

The torso is equal to about 1.75 heads.

The arm and hand is equal to three heads.

Legs equal three heads.

Topic 24
Head and Body Proportions

For example, a "six-head body size" means the character's overall height it equal to the size of his or her head times six.

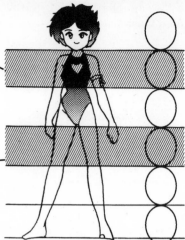

The length of the area between the neck and waist is the size of one head.

The waist to the pelvis is one head.

The thighs to the knees is one head.

The knees to the bottom of the feet is about two heads.

For a five-head body size:

The neck to the waist is the size of the head.

The waist to the pelvis is three-quarters the size of the head.

The thighs to the knees is three-quarters the size of the head.

The knees to the bottom of the feet is the size of a head and a half.

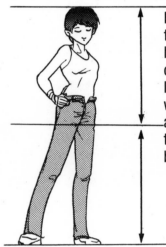

- This is a common method for determining the height of the various parts of the body. Of course, the number of heads used is left entirely up to the artist.

Regardless of the number of heads used, characters look best when the legs are one-half the size of the body.

- Proportions are the ratios of the length of the legs and torso in regards to the head. Proportions are what give the character balance.

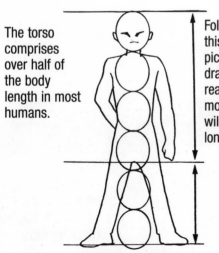

The torso comprises over half of the body length in most humans.

Following this, if the picture is drawn realistically, most torsos will be long.

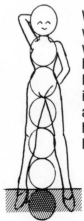

When women wear high heels their legs increase about one head in length.

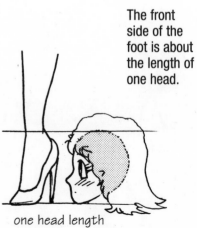

The front side of the foot is about the length of one head.

one head length

Topic 25
Understanding Desirable Proportions

How long should the legs be or where should the waist go?

There must be some kind of ratio...

When drawing human figures, it is easy to give balance to the characters by considering the ratio of the size of the head to the length of the body and drawing accordingly.

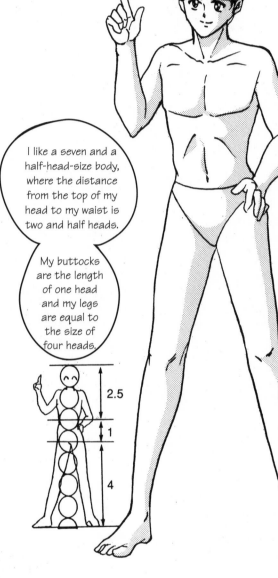

Measure the head of your favorite character.

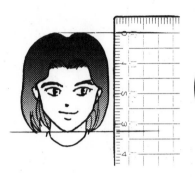

I like a seven and a half-head-size body, where the distance from the top of my head to my waist is two and half heads.

My buttocks are the length of one head and my legs are equal to the size of four heads.

Six head lengths

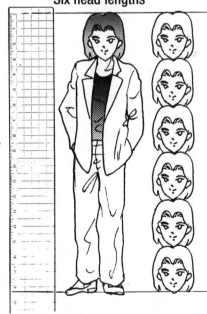

Then measure the height and figure out the head ratio.

2.5

1

4

Use things like the position of the waist or the length of the legs in proportion to the length of the body as reference when drawing.

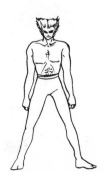

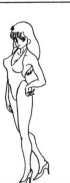

The proportions of other characters are easy to understand when analyzed using the 'head-height ratio' method.

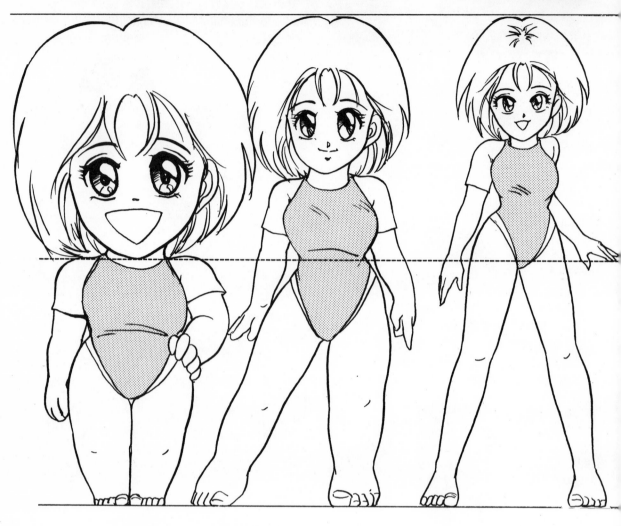

Topic 26
Two to Eight Head Lengths

For four head lengths and above, the balance is in the legs, which are half the length of the body.

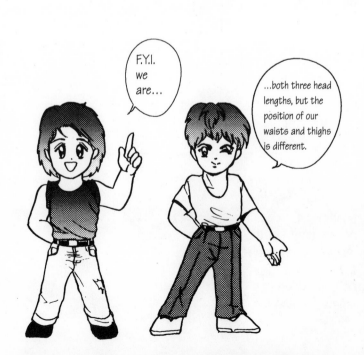

F.Y.I. we are...

...both three head lengths, but the position of our waists and thighs is different.

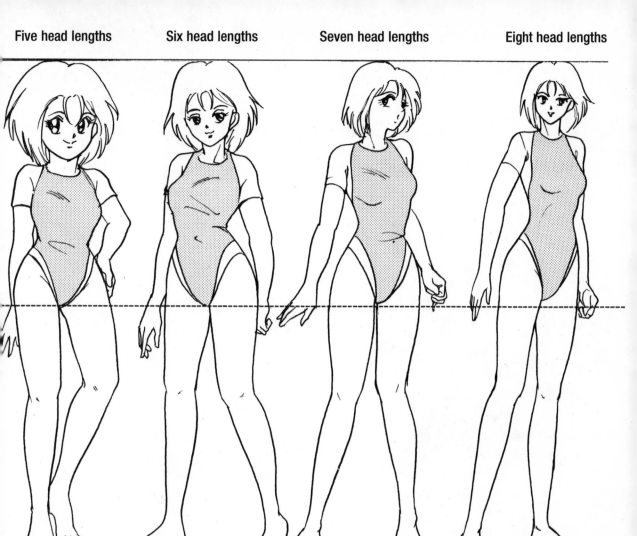

As for human proportions, an infinite variety of human body styles exist depending on the artist and the work.

It's a bit unnatural to have the legs half the body size in three head-length figures.

Change the balance according to your taste.

Two-head-length characters where the legs are half the body height look like little monsters.

Topic 27
Sketching Joints and Full Bodies

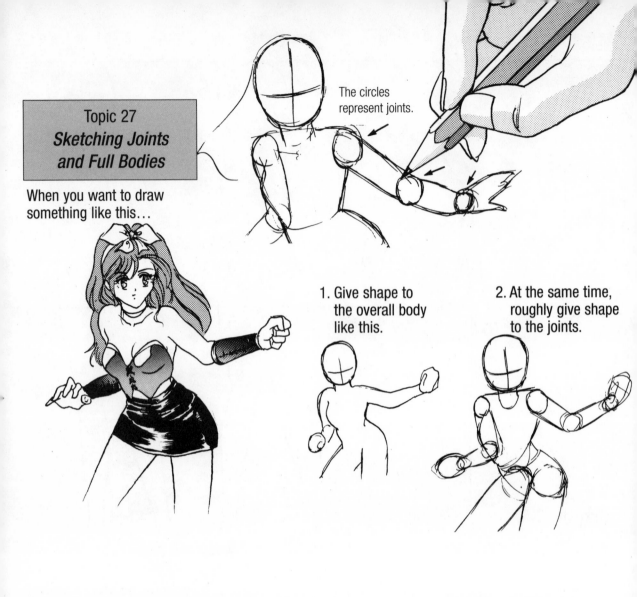

The circles represent joints.

When you want to draw something like this...

1. Give shape to the overall body like this.

2. At the same time, roughly give shape to the joints.

This makes it easy to give balance to the figure and tell how the joints bend.

The pose is completely up to you. Anything goes!

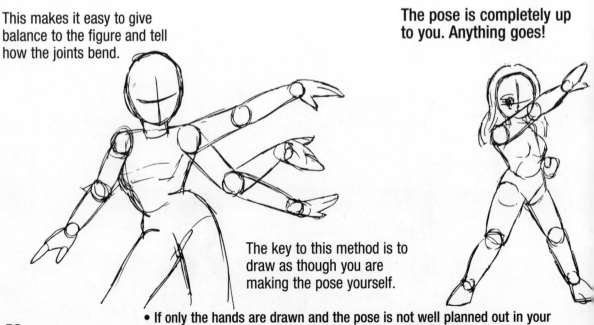

The key to this method is to draw as though you are making the pose yourself.

• If only the hands are drawn and the pose is not well planned out in your mind, the drawing ends up having no life and looks like a robot.

Topic 28
Drawing Heads

1a Give shape to the eyes.

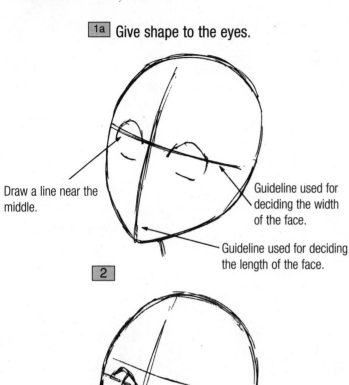

Draw a line near the middle.

Guideline used for deciding the width of the face.

Guideline used for deciding the length of the face.

1b Some people like to start with the nose.

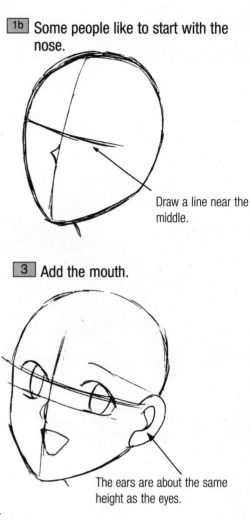

Draw a line near the middle.

2

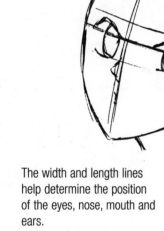

Add the eyes.

The width and length lines help determine the position of the eyes, nose, mouth and ears.

3 Add the mouth.

The ears are about the same height as the eyes.

4 Draw the hair.

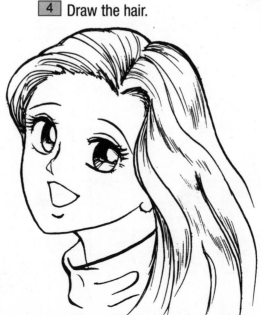

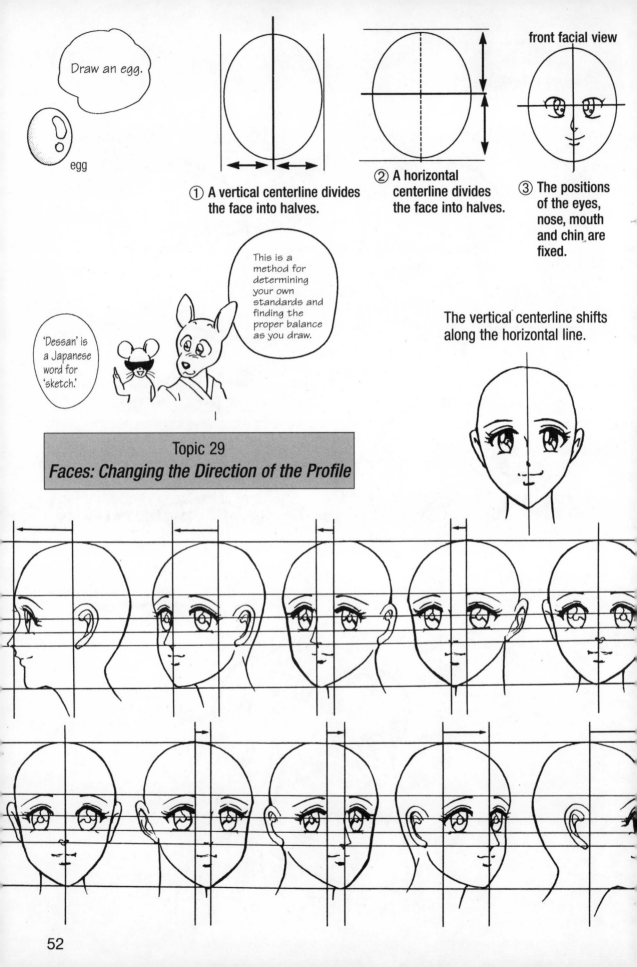

Draw an egg.

egg

① A vertical centerline divides the face into halves.

② A horizontal centerline divides the face into halves.

front facial view

③ The positions of the eyes, nose, mouth and chin are fixed.

'Dessan' is a Japanese word for 'sketch.'

This is a method for determining your own standards and finding the proper balance as you draw.

Topic 29
Faces: Changing the Direction of the Profile

The vertical centerline shifts along the horizontal line.

52

Topic 30
Faces: Upward and Downward

Shifting the horizontal centerline up and down changes the upward and downward slant of the face.

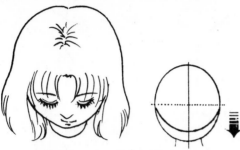

When the face is turned down, the amount of visible hair increases.

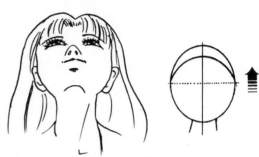

The nostrils and underside of the chin can be seen when the face is looking up.

Something is strange!

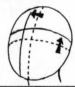

Mixing the movement of the centerlines to create a low-angle view is a technique to make characters look cool.

For example, eyes looking head-on come out like this.

The shape of the eyes changes when looking up and the lower eyelid comes close to making the following shape: ∧.

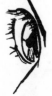

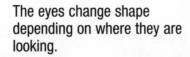

The eyes change shape depending on where they are looking.

Topic 31
Creating the Shape of the Head and Hair

Why are you drawing the heads like that?

Because human heads are like this.

skull

When drawing human heads, the outline of the hair can be shaped along the outline of the head.

Finalizing the shape of the head makes it easy to give shape to the hair.

When the arrows are short, the result is childlike hair.

When the arrows are long, the result is hair with volume.

perfectly shaped hair

skinhead

If the shape of the head is not finalized, the character will end up with a gouged head or strange-shaped skull.

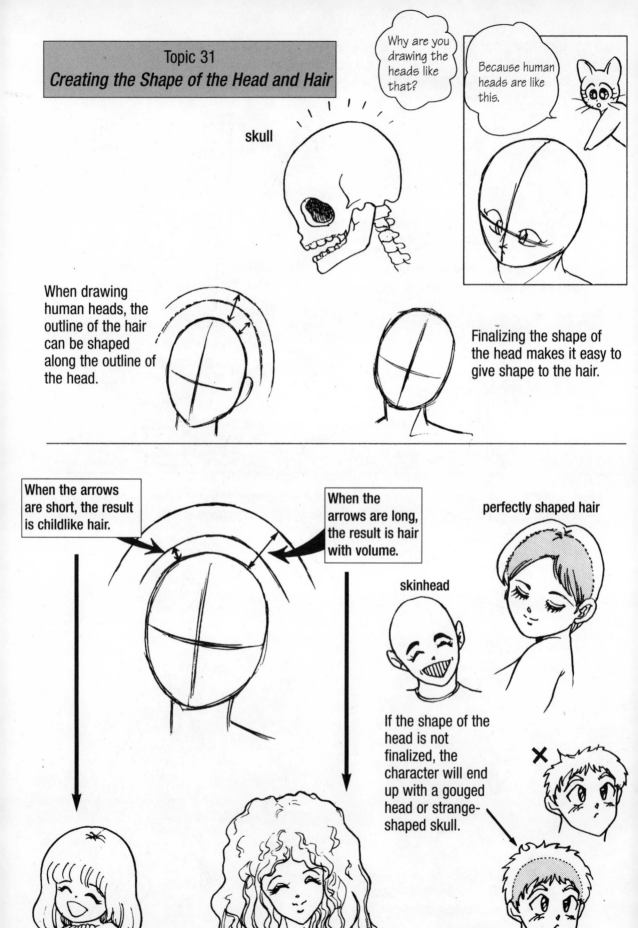

Looking at the drawing through the back of the page makes it easy to tell which parts are right and which are wrong.

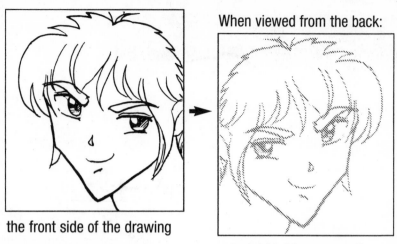

the front side of the drawing

When viewed from the back:

- the height of the eyes are off.
- the back of the head is gouged.
- the cheeks are sunken.
- the position of the chin is off.

Topic 32
Finding the Imbalances in Your Sketches

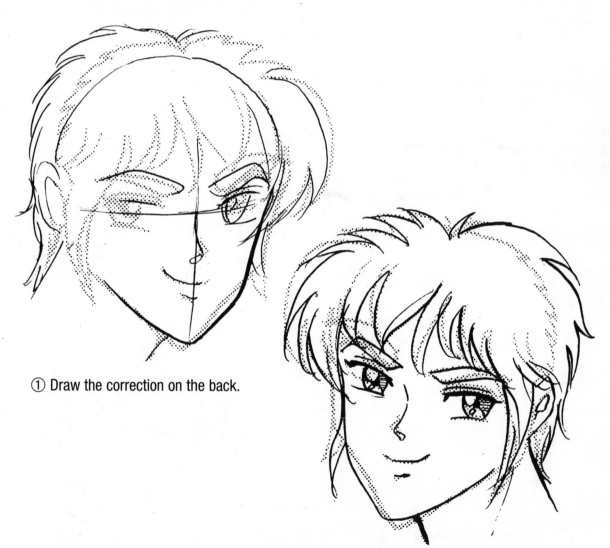

① Draw the correction on the back.

② Turn the page over and redraw the corrected lines.

It is difficult to draw characters viewed from above. Create pictures while looking at reference photographs.

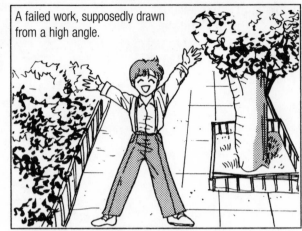

A failed work, supposedly drawn from a high angle.

The sharper the angle, the more the image appears to contract.

• Scenes viewed from above are known as a bird's-eye view - 'fukan' in Japanese. Scenes viewed from below are known as low-angle – 'aori' in Japanese.

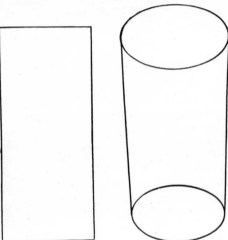

The same goes for human figures; they seem to contract as the angle of view becomes sharper.

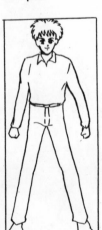
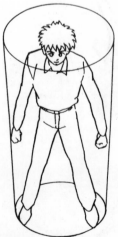
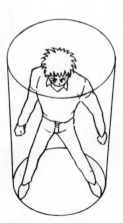
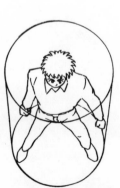

• The visible areas of the upper and lower body change. View the change and be aware of it.
• In addition, just like cylindrical objects, the lines of pant hems and shirt collars curve more and more when viewed from above.

Balance Analysis

In this case, the length of the upper body is twice the size of the lower body.

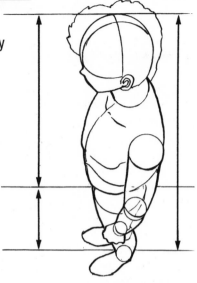

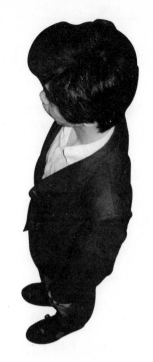

The Trick to Drawing High-Angle Characters

Draw the head and upper body larger. The lower body gets steadily smaller and is shorter than the upper body.

Drawing the character in an inverted triangle makes it easier to bring out the high angle.

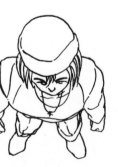

Showing the feet completely gives the drawing a high-angle feeling.

When drawing things such as the hem and belt, which look like horizontal lines when viewed from straight ahead, use curved lines in the shape of a U.

Is it OK to use an HP mechanical pencil for manga?

Most artists use anywhere from HB to 2B lead. If the lead is too hard, though, it will carve into the paper, making it impossible to erase. Many people habitually use HB lead for outlining. When using B to 2B leads, it is easy to get carried away and you may end up with lines that are too strong or dark to erase. Try a variety of leads to find the one best for you.

How about using a calligraphy pen?

Absolutely. Having the will and desire to experiment with different pens and inks is never a minus. Many professional manga artists routinely use calligraphy pens to illustrate such things as flowing hair. Keep in mind, however, that calligraphy ink does not always mix well with white-out, which could cause the ink to run and turn blue. This sort of mixture is very difficult to erase. It's best to test the calligraphy ink on a piece of scrap paper first. Waterproof calligraphy ink works best.

Why does the ink always seem to run?

Sweat and oil from the hands are the leading culprits. While it may take some time, get in the habit of placing a piece of scrap paper or a paper towel under your hands to protect the manga page when outlining or inking. Scrap paper can, however, slip and rub the manga page, thus smearing the illustration. Fix the scrap paper into place with masking tape. Also, always wash your hands before sitting down to work, and wash them often during the course of the job too.

How do I go about collecting reference materials?

1. Take photos of your home, neighborhood, and school or workplace.
2. Travel agency pamphlets and tour books are excellent resources for artists who want to draw manga set in far-flung locales.
3. Encyclopedias and children's books contain a wealth of information and illustrations that are useful to manga artists.
4. Fashion magazines and catalogues are a must if you want to create characters that look cool and stylish.
5. Don't overlook the newspapers, magazines and even the piles of junk mail that are delivered to your house every day. These can be wonderful reference materials.
6. Routinely visit your local bookstores. You never know what you may find hidden away on some corner shelf!

What can I do to keep white-out from drying up?

1. Rather than pouring a dab of white-out into a dish, dip your pen directly into the white-out bottle and then add water to the pen tip, or;
2. Add water directly to the white-out bottle and dip the pen, or;
3. Pour a little water into the cap of the white-out bottle, dip your pen into the bottle and then into the cap.

Chapter 3
Setting the Proper Tone

lined - 'bansen' in Japanese

pattern – 'moyoo' in Japanese

net or seine – 'amitoon' in Japanese

Only ordinary points that look gray in color like this can be referred to as amitoon.

gradation – 'gurade' in Japanese

computer-generated

What would you use to create a red tone on this black-and-white page?

There are many ways!

Topic 34
Know Your Tones

For the most part, shadows on a human face are done in No. 1 tones.

61

31

Use No. 1 tones for yellow.

62

The standard practice is to use No. 2 tones for the red and blue.

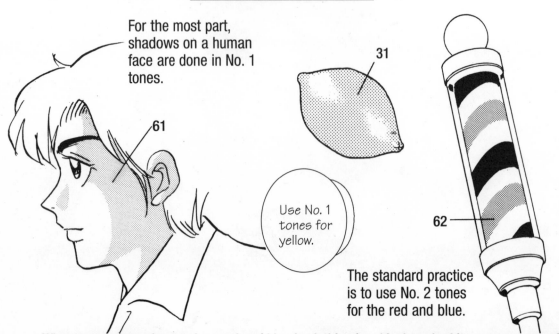

- When expressing colors such as red and blue in clothing in a black-and-white manga, remember to use No. 2 tones. Depending on the scene, black can even look red. However, expressing colors by selecting a particular numbered tone is a matter of taste for each artist.

No. 1 tones are those that end with that numeral, such as 31 and 51. They are light tones.

The number represents the density of the dots. The greater the number, the higher the density.

What does the number on the left stand for?

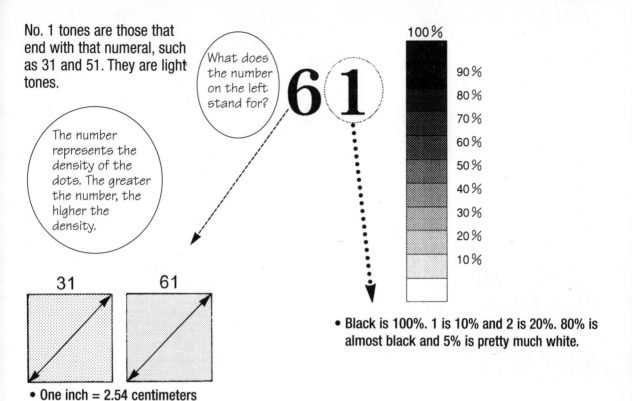

- Black is 100%. 1 is 10% and 2 is 20%. 80% is almost black and 5% is pretty much white.

- One inch = 2.54 centimeters

The numeral on the left stands for the number of dots in one square inch.

Cut and attach each tone type to the predetermined areas.

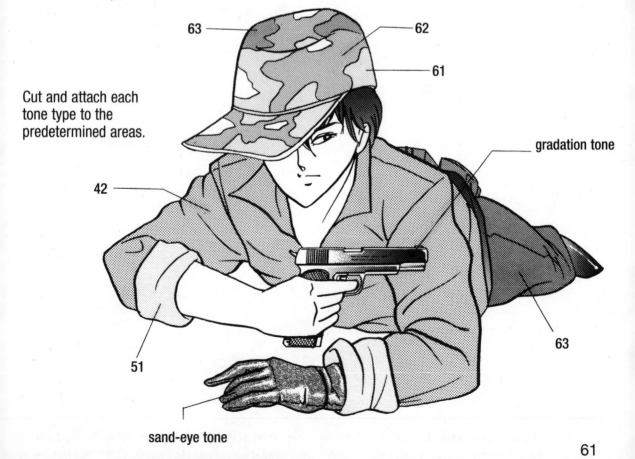

gradation tone

sand-eye tone

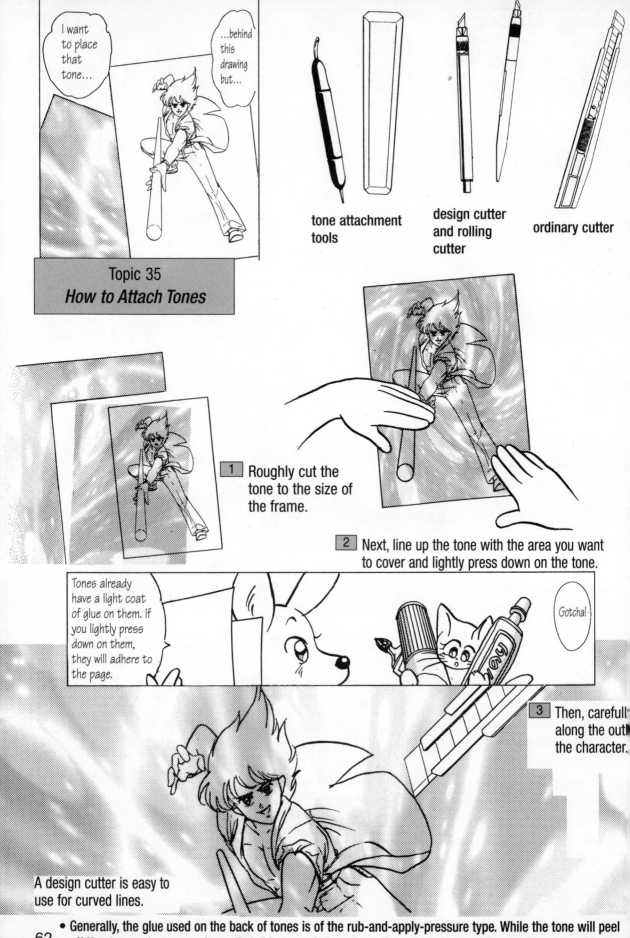

I want to place that tone...

...behind this drawing but...

tone attachment tools

design cutter and rolling cutter

ordinary cutter

Topic 35
How to Attach Tones

1 Roughly cut the tone to the size of the frame.

2 Next, line up the tone with the area you want to cover and lightly press down on the tone.

Tones already have a light coat of glue on them. If you lightly press down on them, they will adhere to the page.

Gotcha!

3 Then, carefull along the out the character.

A design cutter is easy to use for curved lines.

- Generally, the glue used on the back of tones is of the rub-and-apply-pressure type. While the tone will peel off if not enough pressure is applied, this type of glue allows the user to temporarily attach and remove tones

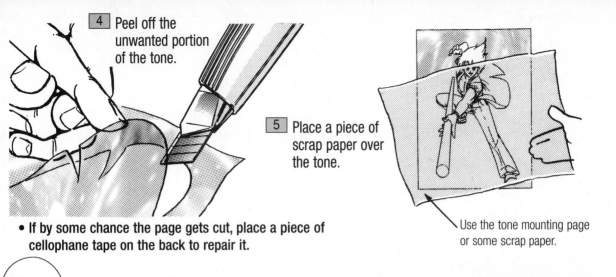

4 Peel off the unwanted portion of the tone.

5 Place a piece of scrap paper over the tone.

Use the tone mounting page or some scrap paper.

• **If by some chance the page gets cut, place a piece of cellophane tape on the back to repair it.**

The tone is perfectly in place!

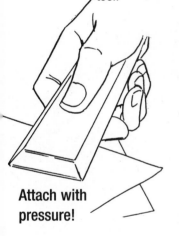

6 Secure the tone by firmly rubbing with a tone attachment tool.

Attach with pressure!

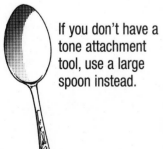

If you don't have a tone attachment tool, use a large spoon instead.

Various background and line effects can be used to convey many different moods, even if the character illustration remains the same.

Character

Add in the background.

With effect lines added in

Tones attached to the character only

Tones attached over the effect lines and etched

Character tones and background tones

Tones attached to the character after the effect lines were added

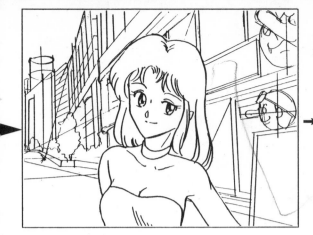

Outlined background

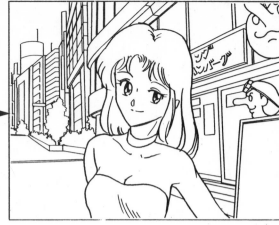

Inked background

Make corrections before tones are attached.

Attached background tones

Background and character tones

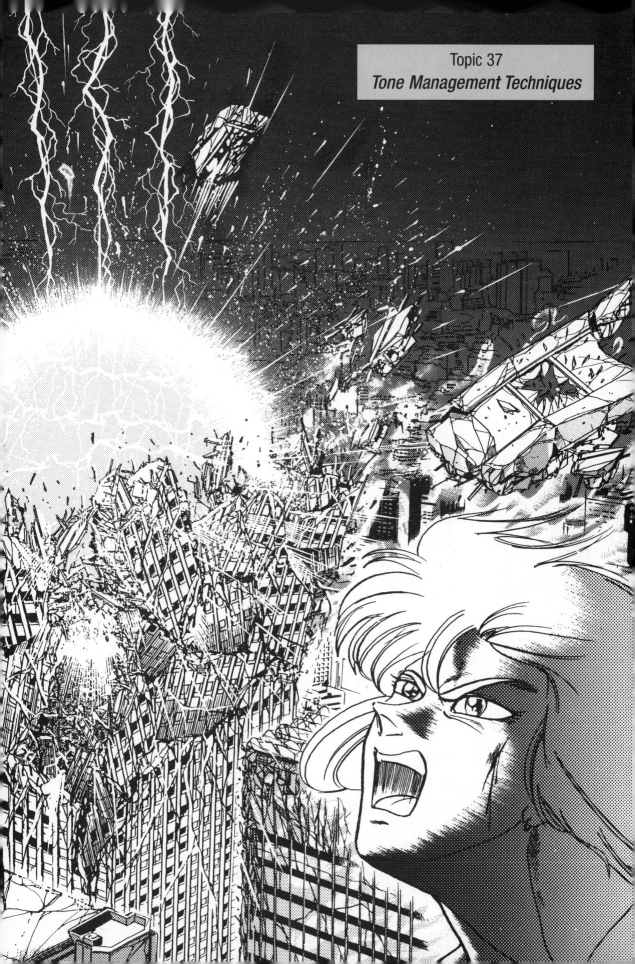

Topic 37
Tone Management Techniques

1 For tone management of auras and the like, first begin by roughly etching.

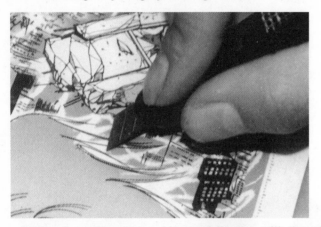

Back side: the part used when etching large sections.

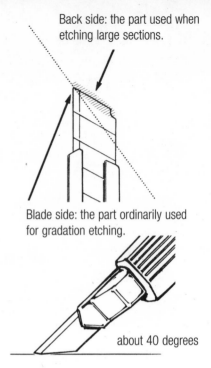

Blade side: the part ordinarily used for gradation etching.

about 40 degrees

- Laying the cutter down a bit, carefully etch with the wide, flat part of the blade (back side) while applying force.
- Hold the cutter firmly.
- Continue to etch with the finished image firmly in mind.

2 Etching and gradating using a cutter

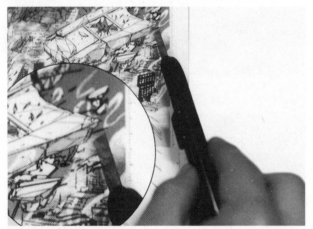

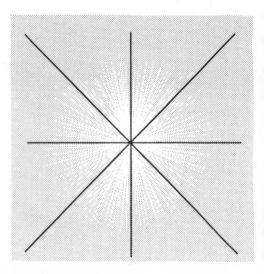

- Use the blade side of the cutter when gradating.
- Hold the cutter lightly.
- As if drawing thin parallel lines, etch rhythmically and carefully.

The angle used to do the above drawing was about 20 degrees.

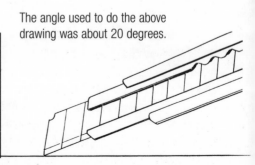

CAUTION
Some angles (crossways 45 degrees) cannot be neatly etched and gradated with tones. To avoid mistakes, as shown in the illustration on the right, lightly draw 45-degree angle lines over the tone with a pencil, and etch at parallel angles.

3 Etching straight lines using a ruler

When attaching and etching tones, it is important to keep the final image in mind from the start as the finishing touches are put on the drawings.

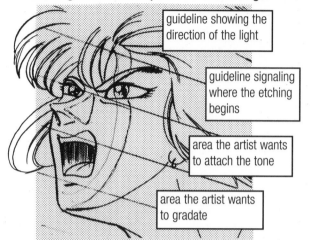

guideline showing the direction of the light

guideline signaling where the etching begins

area the artist wants to attach the tone

area the artist wants to gradate

Areas where tones are not attached are areas where light strikes the drawing.

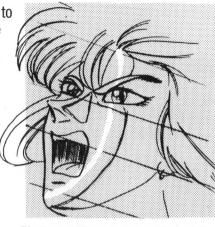

First, roughly etch the outline of the boundary of the white area.

- Hold down the ruler firmly.
- Hold the cutter firmly.
- Lying the blade down results in thick lines and standing the blade up results in thin lines.

lying down a bit
– 20 degrees

standing up a bit
– 45 degrees

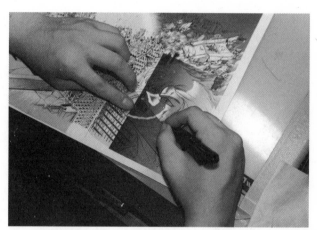

CAUTION
Start by determining where the light is coming from. (The direction of the light acts as a standard guideline for etching.)

- Since light at 45 degree angles will not result in neat etchings, delicately adjust by choosing a direction that can be gradated neatly and etch. While the direction of light in regards to the character in the example above is almost 45 degrees, the artist consciously avoided this angle, instead choosing an angle that works.

- Move the ruler in a parallel manner. (The reason is that when the distance increases between the object where the tone is attached and the light source, the light becomes parallel.)
- Change the direction of the page so it is easy to use the ruler and cutter.

4 Etching radiating lines with a ruler

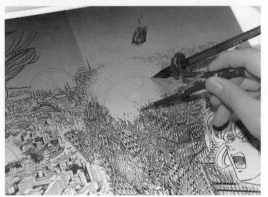

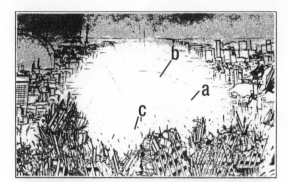

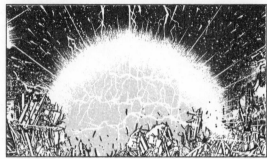

Draw a guideline above the tone. If the guideline is not carefully drawn, especially when illustrating flash explosions such as this, the drawing is likely to end up looking distorted and ill-formed.

Drawing flash explosions freehand and with a ruler.

1. Etch large sections around the area 'a' (arch) of the blast.

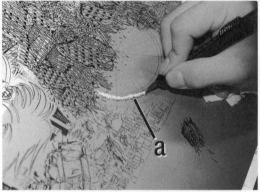

- This time 180 degrees of the tone is used. Etch while being conscious of the center of the half circle.

3. Use a ruler and cutter to create accent lines.

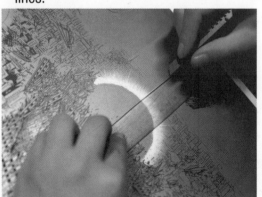

2. Freehand etch while being conscious of the center.

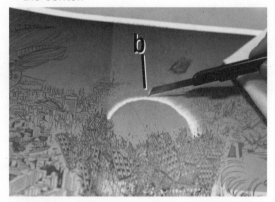

- Carefully etch with a carving rhythm as if drawing invisible lines from the center.
- Set the area 'b' as a target for relieving pressure from the blade.

- Draw the lines steadily from the center.

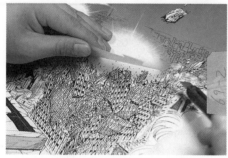

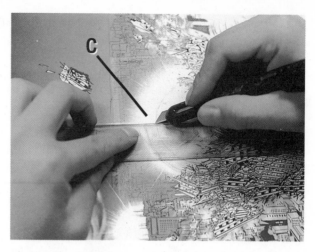

4. Attach a light tone (a No. 51 tone is used here) to the area 'c' and etch toward the center.

Creating flashes with a ruler

1. Draw guidelines for the areas where the white etching begins and ends.

2. Roughly etch the boundary line.

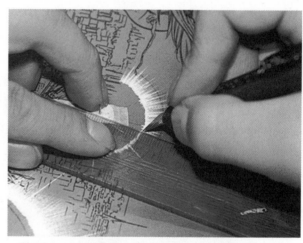

- Placing a thumbtack in the center makes it easier.
- Be careful not to etch the lines too long, releasing pressure as you do.

5 Etching with an eraser

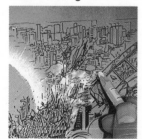

- Use a sand eraser for gradation.
- Adjusting the level of pressure in gradation management using an eraser is difficult and is for advanced users.

After etching large areas for the smoke, blend them into the environment.

Topic 38 *Gradation*	Gradation is known as 'gurade' or 'gura' in Japanese. It is used to express colors other than black.

1 Expressing black

filled in with black only

filled in with black and gradation: use gradation in the areas that are struck by light.

For things like the front windshields on cars, the glass should be thought of as black, with white added for areas that are struck by light. Cut along the curves of the front glass to express the curved nature of the front windshield.

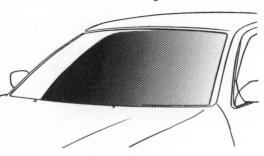

2 Expressing Night Scenes

Gradation can also be used in night scenes.

Be conscious of curved surfaces and reflected light – 'tekari' in Japanese - in metals (especially machinery) when attaching tones.

 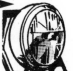

The curved surface of the gas tank can be expressed by attaching gradation tones in the form of a reflection.

Attach another gradation tone layer making sure to avoid 'moare' (a screen pattern caused by the density of the dots). Finally, create a white area to express the light.

- For the headlight area, attach 'belt gradation' from the middle and on down.
- The roundness and reflection in the glass can be expressed by attaching the tone to just half of the object.

A

B

C

Create white by not attaching any tone.

- **Express the metallic curved surface by drawing in scenery that is reflected.**
- **Attach the gradation from the middle and on down.**

- Cutting the tone a bit from the outline brings out the three-dimensional roundness of the metal.
- Belt Gradation – short continuous strips of gradation one to three centimeters in width are often used for eye pupils, metals and window glass.
- Moare – from the French word 'moiré.' A standard manga pattern that is made from laying two tones. If tones of different numbers are used, the 'moare' pattern caused from the density of the dots will appear.

Easy Does It!
1. Pay particular attention when applying tones to areas such as the front fender **(A)**.
2. Use tones sparingly when creating a reflective effect such as on the chrome fork **(B)**.
3. Never apply tones to colorless areas struck by light, such as the upper half of the disc brake **(C)**.

How should ink and white-out be applied on top of tones? Maybe it's just me, but the tones seem to split open.

It is common for tones to split or crack when applying ink or white-out. For the best results, try these methods:
1. After applying the tone, "prime" it by rubbing the surface with a standard eraser (not a tone eraser). Avoid applying too much pressure.
2. Sprinkle lead powder (available at stationery stores) over the tone and rub it in well.
3. Use baby powder instead of lead power.

When peeling off the tone, the paper peeled away too. What did I do wrong?

The fastest and most reliable way to dry a tone is by using a hair dryer. If the tone is over-dried, though, parts that you intended to remove will be stuck to the page. Southbecks, a brand of solvent sold in art stores, can be applied to the back of the page using absorbent cotton. The solvent will seep through the page and loosen the tone on the front. You can also apply the solvent directly to the tone using a synthetic brush. Although the solvent loosens the tone, the glue from the tone will remain on the page and must be cleared away using an eraser or rubber-cleaning product.

How do you cut tones in a straight line?

Use a ruler and an ordinary cutter. In the beginning, the cutter will knick the ruler a bit. Keep practicing until you get used to it. If you are worried about cutting up your ruler, buy one that has metal edges. They cost a bit more but are more durable than those with plastic or wooden edges.

I can't seem to get the right balance of tones to represent shadows on human skin. They are usually either too heavy or thin, and the outlines show through. What should I do?

Use a blue pencil to mark the general area for the tones. As long as you draw the lines lightly, blue pencil marks will not show up when printed. Yellow pencil can also be used as it too will not show up when printed. However, yellow lines are harder to see, so most artists prefer to use blue.

What should be done about tones that peel off?

There are three methods to remedy this problem:
1. Place a piece of scrap paper over small tones and apply pressure.
2. Attach mending tape to a torn or peeling tone.
3. Attach more tone than is needed and then etch away the excess tone. This will increase the adhesion of the tone to the page.

When a large section of tone is removed, the area underneath is sticky and ends up getting really dirty. What should be done?

When tones are removed, the glue remains on the page, attracting pencil lead powder and dust. These minute particles cannot be cleared with an eraser.

Therefore, get into the habit of going over the area with an eraser as soon as you have removed the tone. (Make sure the head of the eraser is clean, though, or the page will be ruined!) Rubber-cleaning products are an even more efficient way of removing the glue.

Chapter 4
The Art of Storytelling

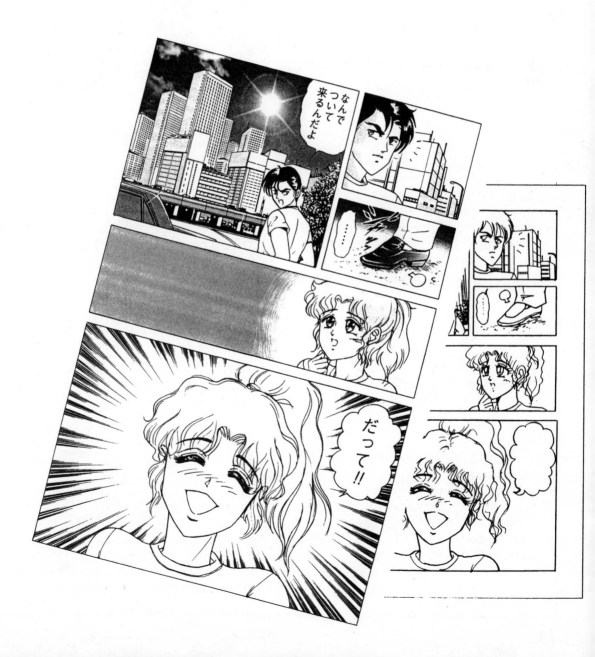

1 Proposal draft - 'neemu' in Japanese

Once the proposal draft is done...

...the remaining procedures are almost the same for all kinds of manga.

Some people like to roughly outline the characters and dialogue balloons while dividing up the frames.

2 Divide the frames on all of the pages.

And some people like to divide up the frames and outline the dialogue balloons one page at a time.

3 Roughly outline the characters and dialogue balloons.

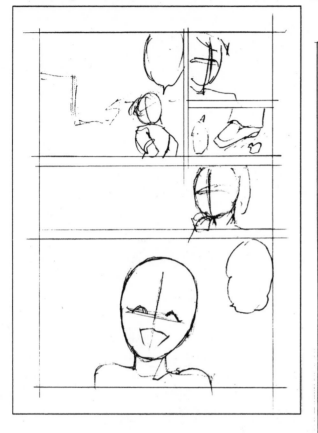

4 Draw the outlines of characters.

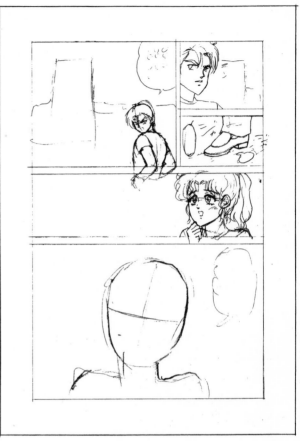

Other artists prefer to ink the frames and balloons first and then move on to the characters.

And some choose to ink all the outlines and then do the frames and balloons.

- The 'neemu' acts as a proposal draft with actual frames, pictures and dialogue on which the manga is based.

5 The character outlining is done.

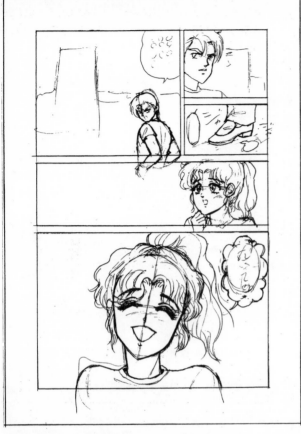

The mood of the outlining really depends on the artist. Outlining is done while methodically erasing the rough lines, and for the most part only the artist can tell the difference between the rough draft lines and outlines.

Place scrap paper or tissue paper over the page when inking.

6 Ink the characters.

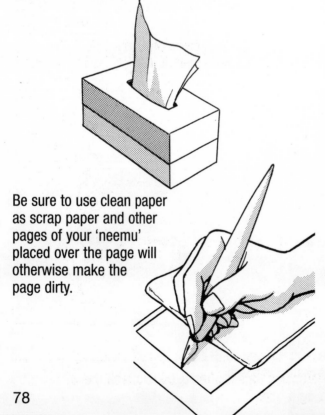

Be sure to use clean paper as scrap paper and other pages of your 'neemu' placed over the page will otherwise make the page dirty.

7 Use an eraser depending on the situation.

Ordinarily, an eraser is not used until the backgrounds have been inked and the white-out and tones are applied. However, it may be necessary to use an eraser if you cannot draw the background without outlining it first.

Make sure the head of the eraser is clean!

8 Outline the backgrounds.

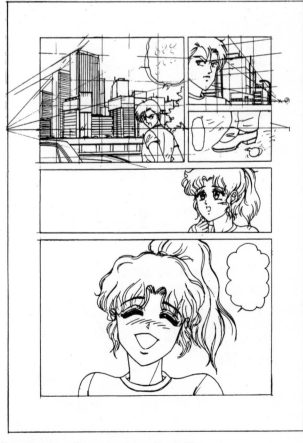

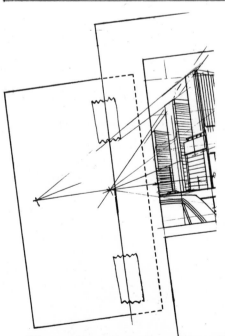

When using perspective while outlining the background, you may need to attach another piece of paper for drawing the vanishing points.

Use scrap paper for this. Masking tape is often used to attach the page, especially when using a ruler.

9 Ink the backgrounds.

Use scrap paper and masking tape when inking the backgrounds too.

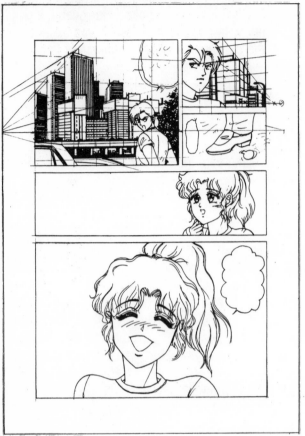

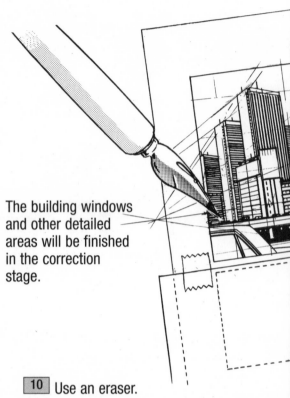

The building windows and other detailed areas will be finished in the correction stage.

10 Use an eraser.

Use an art eraser (kneaded eraser) to lighten or erase marks drawn with a fine-tip pen.

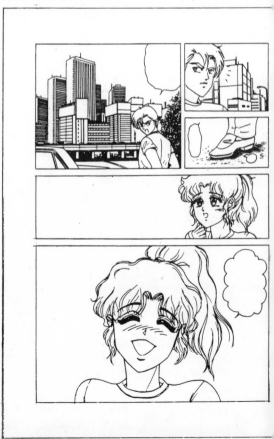

11 Add in effect lines and sound effects.

Fill in the hair with black at this time.

After making a simple, rough outline in pencil, ink in the effect lines and sound effects.

fine-tip pen used for outlining

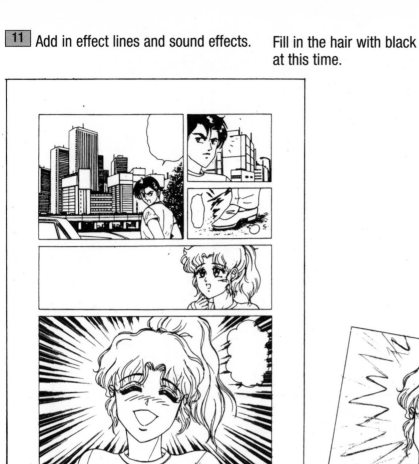

Neatly erase any smudges and frame lines that stick out.

Add white-out to the buildings and other detailed areas. Once the background is complete, you can begin the final stage: adding tones.

- Use a brush to add white-out to the pen tip.
- This cannot be done with oil-based white-out.
- Be careful not to put too much white-out on the tip.

12 Make corrections with white-out.

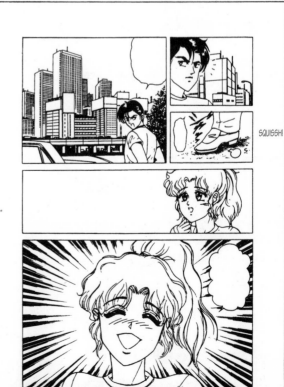

13 Tone management process.

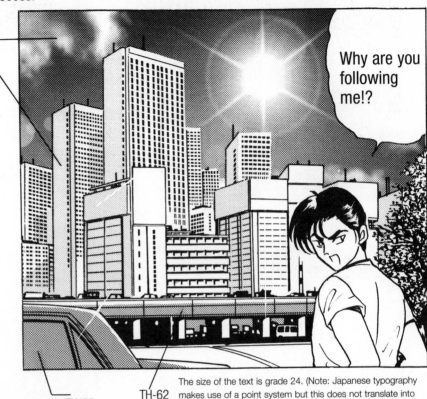

For the most part, background tones are attached first and then the characters are done.

Attach the tones while taking into account things such as the ease of viewing and visual directions in the overall balance of the frame. You may find yourself if adding or leaving out tones in areas that you hadn't planned on.

TH-521

TH-61

TH-53

TH-62

Why are you following me!?

The size of the text is grade 24. (Note: Japanese typography makes use of a point system but this does not translate into the same sizes expressed in English typography.)

C-40 is a Letraset™ tone and TH tones are design tones.

TH-61

TH-126

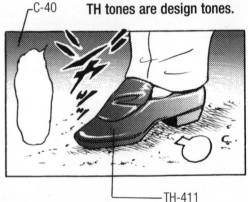

C-40

TH-411

• This page was created using B4 size paper, which is the size used for submission to manga magazines.
• The work will be reduced 82% when it appears in a commercial manga magazine.

Topic 40
Proposal Drafts (Neemu)

A 'neemu' is the proposal draft or blueprint for a manga.

first draft

The concept of the first draft is to make the material simple enough that even a child can understand it. However, this results in making the personality of the character too childish and is not suited for the intended audience.

The basic concept and plot in the second draft are the same as the ones in the first draft, right?

• Some people like to carefully draw the sketches in the rough draft. Sometimes they are drawn with such care that they can be enlarged and used as outlines for the final manga.

This is the first-stage neemu for the introductory section of a manga.
The introduction sections contain the most important and difficult parts of a manga. Found on page one, they are:

1. character introduction (personality)
2. story setting
3. character relationships
4. clearly defined direction or theme of the story

This must also be drawn so that the reader will want to know more.

The drawings are really bad huh?
They are fine as long as the content can be understood.

second draft

third draft

The content of the third and fourth drafts remains much the same as it was in the first draft. However, the trial-and-error process continues, with the artist changing the characters' sex, their manner of speech, and their relationships to one another.

fourth draft

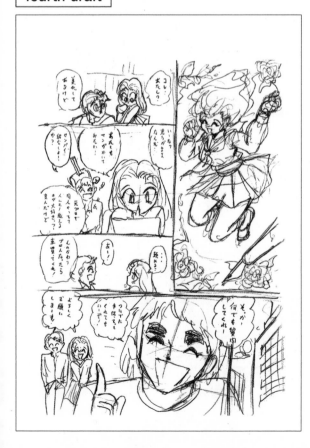

Things have been rearranged from the first draft.

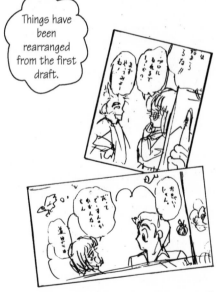

In the second draft, the girl is too pushy and calculating, and the girl in the third draft is too selfish and not cute enough. As a result, there are times when the character and the character relationships are settled by letting things ride through the middle.

Topic 41
Creating a Proposal Draft

There are a lot of people who want to draw manga but don't know how to create a rough draft or write a story. So how does one go about creating a rough draft? Professional manga artists face the same challenge.

First, try drawing.

Then add in some dialogue.

Now is the time.

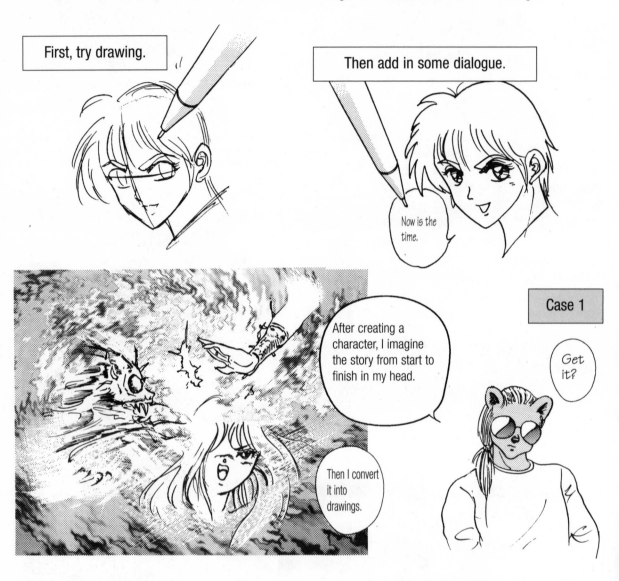

After creating a character, I imagine the story from start to finish in my head.

Then I convert it into drawings.

Case 1

Get it?

The initial images steadily change as you draw but…

…the point is to flow with that energy and keep drawing!

I like to take the story in my head and...

...put it into words like in a novel.

Author's Rough Draft

Then, outside the window, the bright red setting sun in the dusk of the evening appeared and the clouds hugged the sun's solemn light. The silhouette of the main character appears against the red-painted sky. He said, "In the end, cling to what you create." The golden light from a small box in his left hand caught his eye as he looked and put his finger on the switch. Then he...

Case 2

Illustrate the setting and then add dialogue, as if you were shooting a movie.

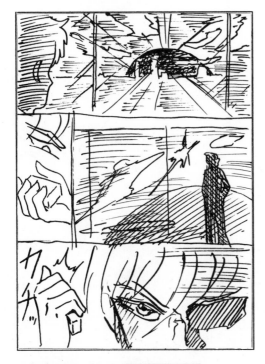

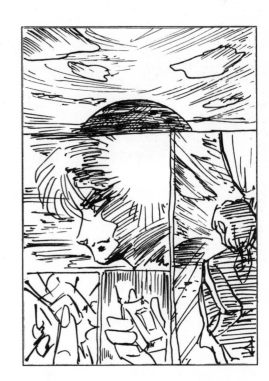

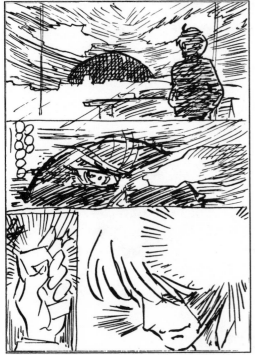

When trying to convey an image or mood...

...it's tough to let the illustrations do all the work.

• While putting your ideas and images into words, a lot of times the story starts to write itself.

I put the images in my mind into a script format.

Case 3

character	dialogue	setting
A B	"Stop toying with me." looking back	
A AB	"I love you." long shot: raging wind	
C	new character enters doing a handstand "How stupid. You pervert." "Hold on…Who on earth do you ---"	

As if watching animation or a television drama:

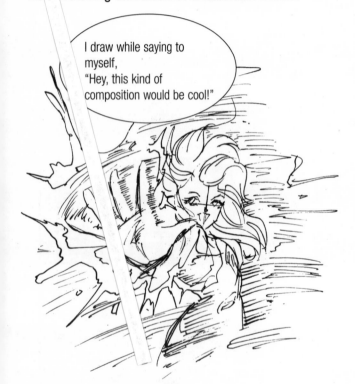

I draw while saying to myself, "Hey, this kind of composition would be cool!"

While it is easy to explain everything with dialogue, the task is to see how much can be expressed with the visuals.

For example,

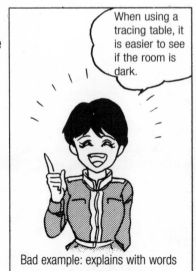

When using a tracing table, it is easier to see if the room is dark.

Bad example: explains with words

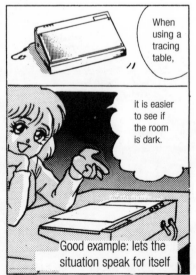

When using a tracing table,

it is easier to see if the room is dark.

Good example: lets the situation speak for itself

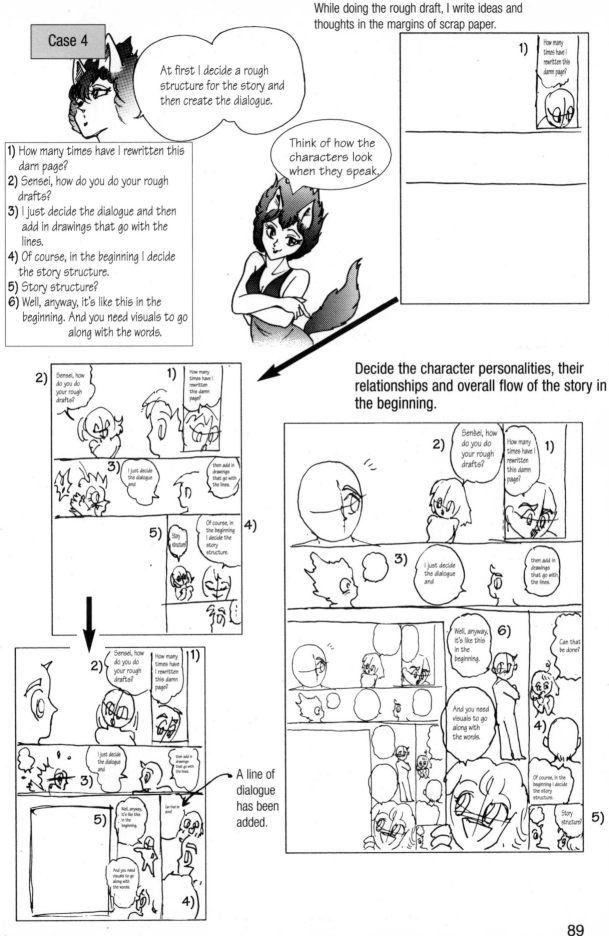

the cover of a closed manga magazine

Topic 42
Frame Allotment Theory
– Left and Right Pages

As you may already know, Japanese manga magazines are read from the right to the left. In most cases, the cover page appears on the left side.

title

ふらいんぐ
ラブ・ストーリー

飛龍　昇

つづく

name of the author

Numbering manga pages

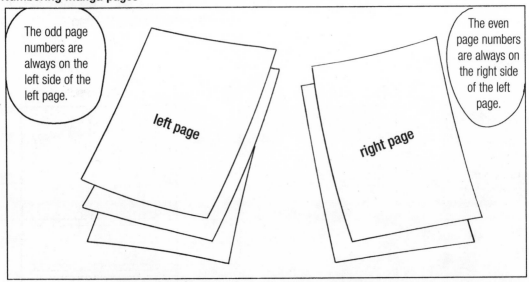

The odd page numbers are always on the left side of the left page.

The even page numbers are always on the right side of the left page.

left page

right page

• While there are some manga with an introduction page on the left and then the title page on the right or with two-page spreadsheet, the first page usually appears on the left side. Please adhere to this rule.

The closed section of the manga is known as the throat – 'nodo' in Japanese. Tachikiri - an illustration drawn to the edge of the page – cannot be used in the throat area.

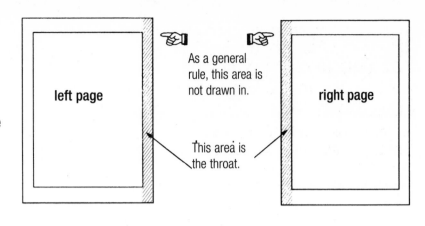

left page

As a general rule, this area is not drawn in.

This area is the throat.

right page

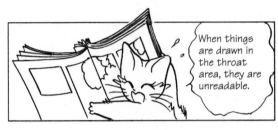

When things are drawn in the throat area, they are unreadable.

When reading manga you might see things like this, but as a general rule, dialogue balloons usually appear inside the frame even with tachikiri illustrations.

• The must-see areas – the face and dialogue – are drawn well within the frame.

As shown here, ordinarily the odd-numbered pages appear on the left and the even-numbered pages appear on the right.

odd pages

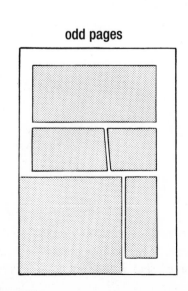

even pages

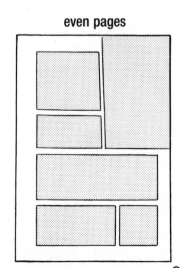

91

Topic 43
Transferring the Proposal Draft to the Manga Pages – Part 1
Tachikiri and the Left and Right Pages

After creating a proposal draft, consider how the pages would look if they were in a closed book. When outlining, keep in mind whether the page will be on the left or the right.

For example, even if the entire page was used in the proposal draft...

...if tachkiri (on the left page) is used, the layout will look like this.

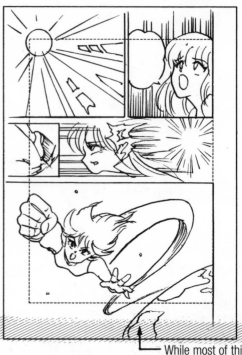

Without using tachikiri and placing the drawings in an orthodox manner, the page ends up like this.

While most of this will not be shown when made into a manga magazine, tachikiri can be used when you want to emphasize an illustration.

Reasons to Use Tachikiri:
1. When you want to add force to the pictures
2. When you want to call attention to a particular frame
3. When there are a lot of frames on one page and you want to make each frame as large as possible

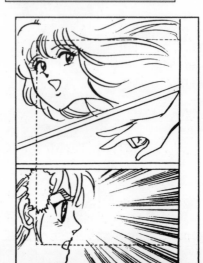

If you mistake the left page for the right page, the left page turns out like this.

This page is correct.

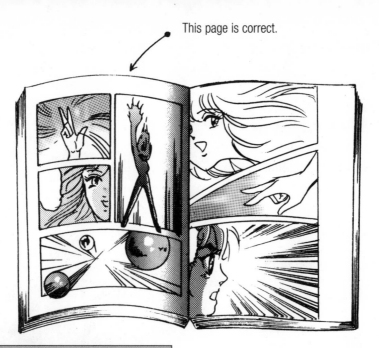

Topic 44
Transferring the Proposal Draft to the Manga Pages – Part 2
The Sizes of the Pages are Different

The sizes of the pages are different...

If the sizes of the pages are different when transferring the proposal draft to the manga pages, you may not know how to handle this at first.

Just do the drawing a little larger! ➡

• Some people like to use B4 pages from the beginning for the rough draft or make photocopies enlarging the B5 paper to B4 size.

Your final illustrations will definitely look different than the initial sketches. Don't be afraid to modify characters, backgrounds, even dialogue. In fact, some artists have changed everything by the time they finish a composition.

when transferred to manga pages

The work comes alive.
The overall look will change depending on the timing, your mood and feelings!

original proposal draft

Topic 45
Correcting Frame Allotment
– Notes on Page Structure

When creating a proposal draft, artists often find themselves using similar frame allotments on each page. Instead, try to vary the frame allotment.

left page **right page**

The left page with changes made to it.

When changing the frame allotment, it is easier to make changes if you first decide what frame you want to enlarge, then decide which frames can be made smaller.

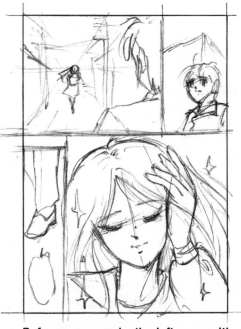

Reference example: the left page with changes made to it.

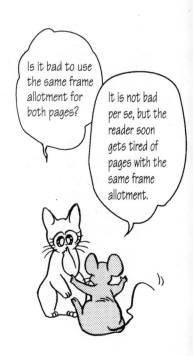

Is it bad to use the same frame allotment for both pages?

It is not bad per se, but the reader soon gets tired of pages with the same frame allotment.

Big Frames = Important Frames

• The standard manga has 5 or 6 easy-to-view frames per page. In general, explanatory scenes require more frames than do action scenes.

Topic 46
How to Prepare Large Frames

① The enemy fires.
② The main character strikes the bullet down.

This explanation does not seem to correspond to the illustrations on the right. It needs to be clarified and rewritten.

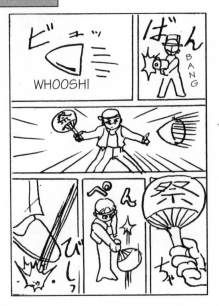

The scene where the main character's special powers are displayed is naturally considered the highlight scene.

Each and every page should have one frame that stands out from all the rest. Such core frames are most conspicuous in action manga but can be found in all genres of manga.

Each page should also have what is considered a climactic frame. (More often than not, the climactic frame will also be the largest on the page.) It is also important to use a variety of frame sizes and shapes to keep the reader from getting bored.

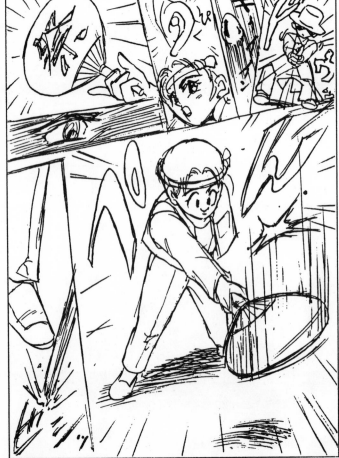

In this case, where the bullet comes flying into the scene, one small frame is sufficient. Concentrate more on emphasizing the feeling of tension in the scene with your frames.

• climax - a frame larger than the others is used to catch the reader's eye.

When illustrating a gunfight or similar battle, it is acceptable to continue the action over a couple of pages before bringing it to a conclusion in a large climactic frame.

The finished work is on the next page. →

Another technique is to use a small frame before a big one to bring the larger frame to life.

Even when the frames are the same size, using close-ups of the characters...

...can make the frame seem bigger than it really is.

Carefully choose which scenes will appear in big frames.

- main character entrance
- new character entrance
- setting or scene introduction
- setting or scene change
- climax, special techniques
- final scene
- emotional events and changes of heart for characters.

- Expressions such as 'Oh no!' and 'Wow!'
- surprise (joy/sadness)
- psychological changes or scenes that bring about these changes
 →some kind of setting
 →something said
 →a confession

- Most people read manga by instinct without following any particular logic. It is the author's job to decide which frames are important to emphasize. To do this, consider the following:
 - What kind of message do you as the author want to convey?
 - What information does the reader need to follow your story?

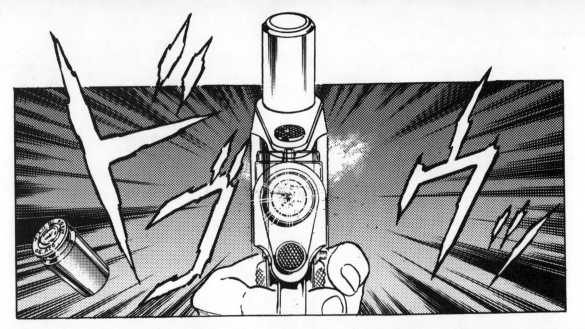

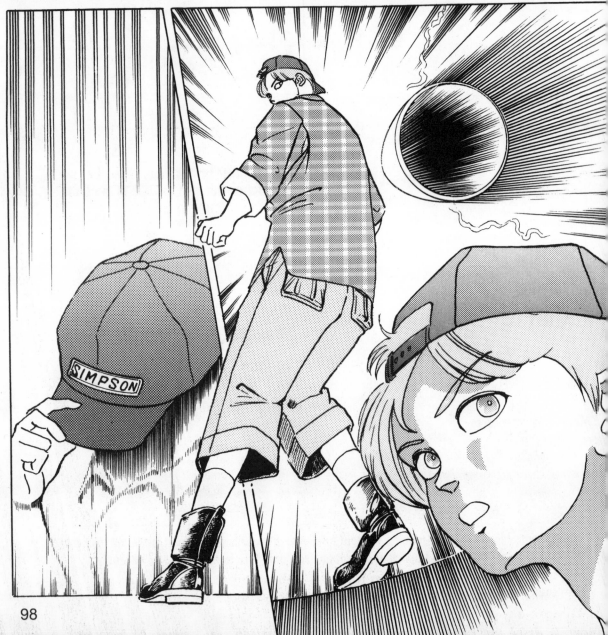

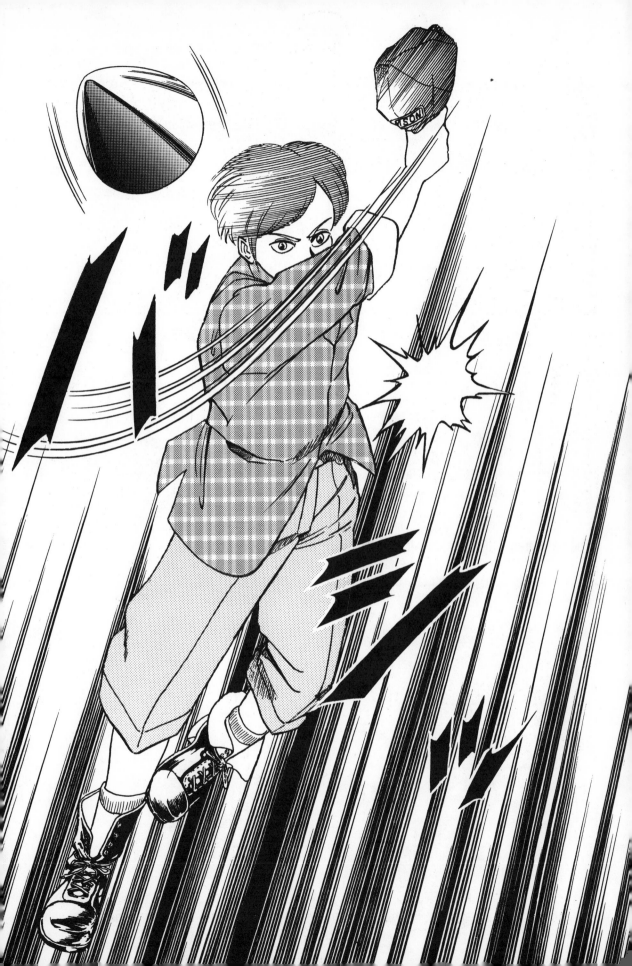

Topic 47
Frame Spacing and Border Widths

Although there is no set rule for determining frame spacing and border widths, the following examples can be used as a yardstick.

Young men's menga

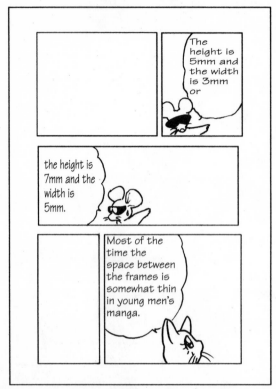

The height is 5mm and the width is 3mm or

the height is 7mm and the width is 5mm.

Most of the time the space between the frames is somewhat thin in young men's manga.

Children's manga / Young boys' manga

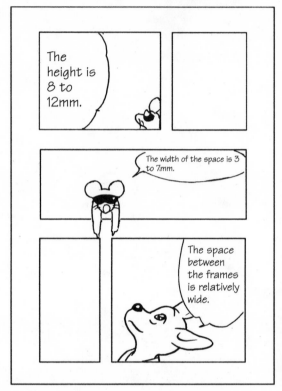

The height is 8 to 12mm.

The width of the space is 3 to 7mm.

The space between the frames is relatively wide.

The basic frame allotment is decided based on the ease of visibility; however, what makes something easy to view varies from person to person and is determined by one's tastes.

For beginners, it is a good idea to use consistent spacing between frames.

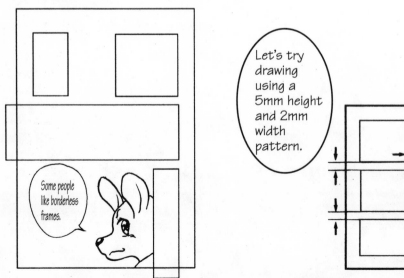

Some people like borderless frames.

Let's try drawing using a 5mm height and 2mm width pattern.

Frame allotment and style will change depending on what the author wants to express. There are a lot of exceptions to the rules and frame variations in shoujo (young girls') manga, where many things are left up to the author's sensitivity.

Some artists like thick borders, others prefer thin ones.

So border width is really up to each person?

It depends on the drawings and taste!

Good example

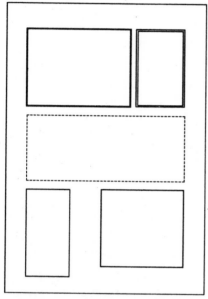

Carefully draw lines of uniform width using a ruler.

Bad example

There are times that you will want to change the thickness of the lines from one frame to the next to add a little flair to the page.

Unless you are using effect lines, make sure all four sides of a frame are equally thick or thin.

Drawing pens make it easy for beginners to create uniform lines.

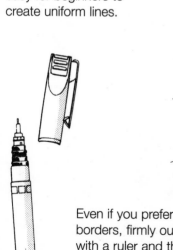

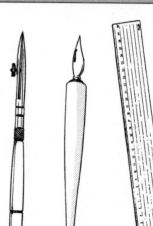

Borders are generally drawn with a pen and ruler. Some artists prefer to use a drawing pen or fine-tip pen.

Even if you prefer hand-drawn borders, firmly outline the frames with a ruler and then trace them.

• **Artists seldom use hand-drawn frames, which create a different effect than sharp ones drawn with a ruler.**

Bad example

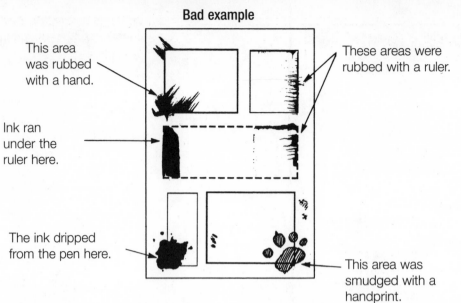

This area was rubbed with a hand.

These areas were rubbed with a ruler.

Ink ran under the ruler here.

The ink dripped from the pen here.

This area was smudged with a handprint.

Be sure to place the ruler like this when drawing frame lines with a pen and ruler.

Then, place the pen in a straight, upright manner like this.

A hair dryer is useful for drying ink.

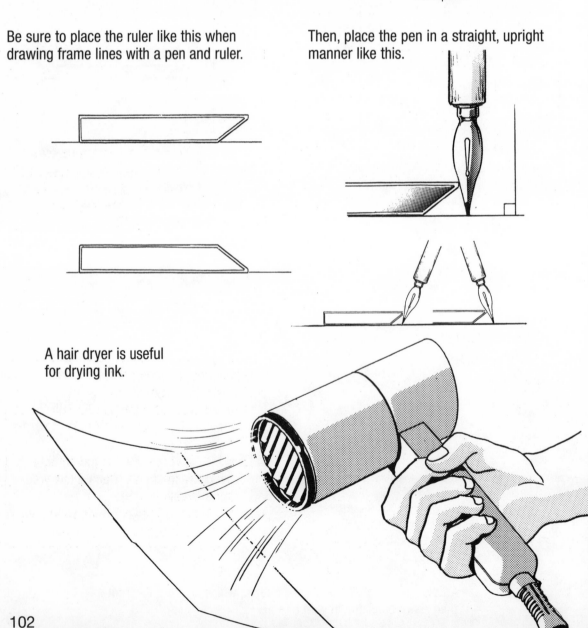

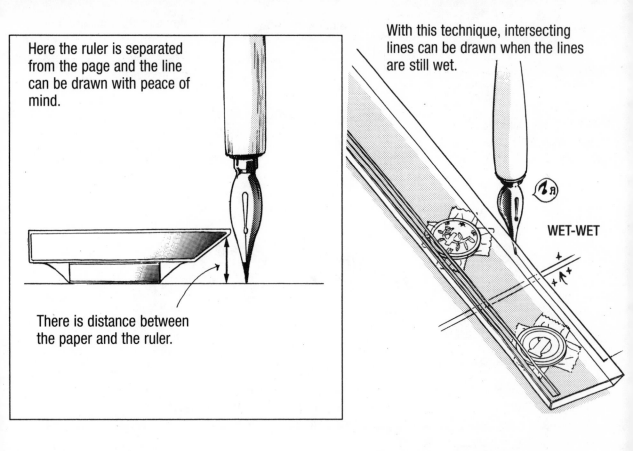

Here the ruler is separated from the page and the line can be drawn with peace of mind.

There is distance between the paper and the ruler.

With this technique, intersecting lines can be drawn when the lines are still wet.

WET-WET

How's this?

Easy does it!

When using a ruler, be careful not to use too much ink.

Coins attached to a ruler makes for a unique item.

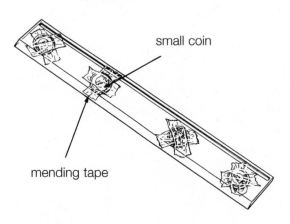

small coin

mending tape

Measures and countermeasures:
Be relaxed but careful!
1. If ink drips from the pen tip, rub the tip against the lip of the ink bottle to wipe away excess ink.
2. After drawing a line, be patient and allow the ink to dry. Don't allow wet ink to smear.
3. If you get ink on your ruler, wipe it well with tissue before using it again.

Most artists decide on the size of the balloons after writing the dialogue.

Make sure the balloons are roomy enough to accommodate the text, and that the words are large enough to read.

Like this.

Like this.

Japanese characters

The size of each letter is generally 5mm by 5mm.

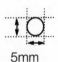

5mm

Since the drawing will be reduced about 80% when printed in a manga magazine, the text will end up about this size.

4mm by 4mm

At times the size of the dialogue balloon is decided by putting in circles for each of the letters.

If each circle is 5mm by 5mm then 19 letters of dialogue can be contained in a 25mm-by-30mm balloon.

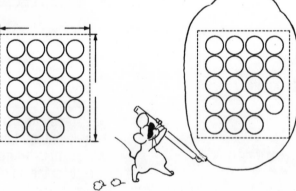

The shape of the balloon helps set the mood. Learn which shapes best convey a sense of joy, sadness, surprise or anger.

I like it.

I like it.

I like it.

I like it.

Topic 50
Flashes

Flashes are used to express strong emotions. Japanese artists call these dialogue balloons "uni" because they resemble sea urchins ("uni" in Japanese).

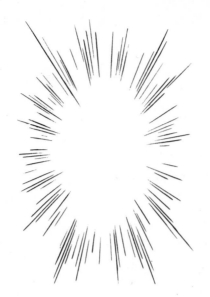

tools: ruler and pen

1 Draw the dialogue balloon with a pencil according to the number of lines it will hold.

2 Mark the center point.

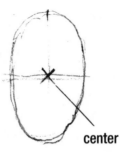

center

Use masking tape to attach the head of a thumbtack to the center-point of the flash balloon. You can then rest the edge of your ruler against the pin, assuring that the ruler doesn't slip as you draw the radiating lines.

Draw the lines with a ruler and pen the same way you would draw emphasis lines.

A. from the inside out

B. from the outside in

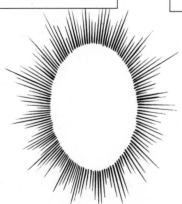

Lines drawn from the inside out from the center. Decide the image you want in your mind and firmly draw the lines along the edge of the dialogue balloon.

center

Lines drawn from the outside in toward the center. This is an advanced technique where the pens lines sharply thrust in.

• **While it is easy to draw these with a fine-tip pen, if the lines on the flashes are not sharp, they are meaningless. It is best to use a new pen.**

I've heard that it's OK to pierce the page from the underside with a thumbtack to serve as a guide when drawing emphasis lines. Is this acceptable?

If possible, attach the thumbtack to the front of the page to avoid making a hole. However, if there is no room for the tack on the front, it is OK to punch the tack through the back. When you've finished drawing the lines, cover the hole with a piece of cellophane tape. Then cover the hole on the front with white-out. (If the punch mark is raised, press it down with a tone smoothing tool.) Afterward, it will be almost impossible to tell there was a hole.

Is India ink best for coloring in black?

This is a matter of taste. Illustrations colored in India ink look perfectly black on the page, and are therefore very pleasing to the eye. However, pages done in permanent black felt-tip markers look exactly the same as those colored with India ink once the pages are printed. In fact, permanent felt-tip markers have become the standard in manga, probably because of the hardness of the pens. Use fine-tip pens for the thin lines and thicker pens for the heavier lines. Still, it's a good idea to try to use India ink as well. Of course, it doesn't hurt to become proficient in the use of both India ink and felt-tip markers.

I peeked at a friend's manga illustrations and noticed a bunch of Xs here and there on such things as the character's faces and clothing. What are those marks?

The Xs probably mark places that will later be filled with black. Busy artists often use X marks to remind themselves to color in certain areas of their illustrations later on. Such marks are also used to mark areas that an assistant will work on. Red pens, whose ink will appear black when photocopied, are usually used to make X marks.

Why doesn't my pen work when I try to draw thin lines over an area corrected with a water-soluble correction fluid?

If you need to draw thin lines over a corrected area, make sure you use an oil-based correction fluid. If, however, you mistakenly use a water-soluble correction fluid, simply wait for it to dry and scrape it away with a cutter. You can then correct the area again with an oil-based fluid and draw lines over it once the fluid has dried. Be aware, however, that it can be difficult to draw lines over dried oil-based correction fluids as well. In some cases, it might be easier simply to start the drawing over again.

What are grades and what is a grade chart? Are manga given grades like those I received in school?

Don't worry: Your manga won't be given grades such as those you received in school! Grades are the font size of the text. The word "grade" is commonly used in the printing industry. The text used in this paragraph, for example, is grade 13. A grade chart shows several text sizes side by side, and is useful when deciding what size text to use when adding dialogue to a manga. In general, manga on B4-size paper use grade 24 to 28 type, while manga on A4-size paper use grade 14 to 20 type.

I think my illustrations look great, but my handwritten dialogue doesn't look so hot. What should I do?

When you submit your work to a publisher, your handwritten text will be fine. In fact, you can even compose the dialogue on a word processor or computer, print it out and paste it into the balloons. When the manga is ready for publication, the publisher will have the dialogue drawn by a professional text illustrator.

Chapter 5
Beautiful Backgrounds

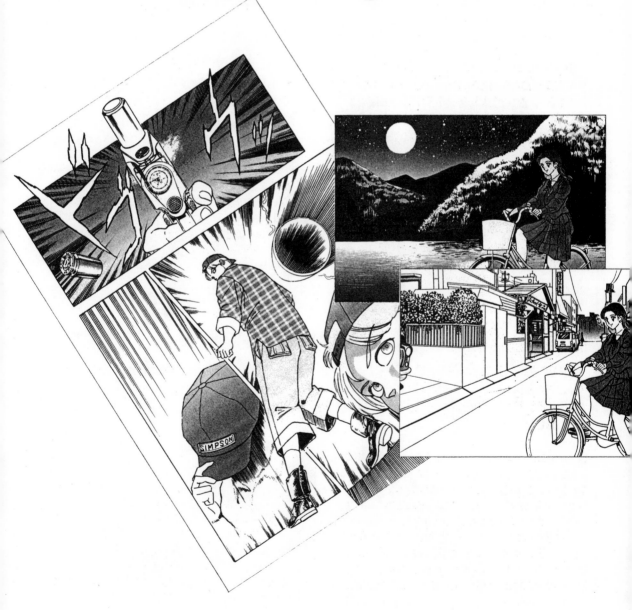

Topic 51
The Set-Up – When and Where

In storytelling, it is essential to explain the five Ws: who, what, when, where and why. Novelists do this with words. Manga artists, however, can use background illustrations to tell much of the story

One of the most important aspects of drawing manga is knowing how to convey a sense of time and place.

Once upon a time...

Anyone home!

I read your rough draft, but where is this place?

Uhhh?

SCREEK

If you are producing a manga based on historical fact, research the period beforehand so your drawing and dialogue will be accurate. Likewise, if your manga is set in an imaginary world and based on fantasy, it is still to important for the story to have a degree of realism to which the reader can relate.

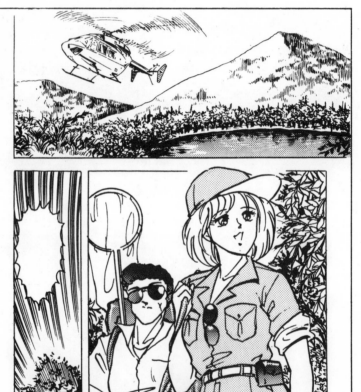

The reader can get the pertinent facts with only one look at this manga.

- You might even want to create a distant planet that resembles present-day living in your own country.
- The 'when' and 'where' of the setting can be easily expressed by showing something like a school.

108

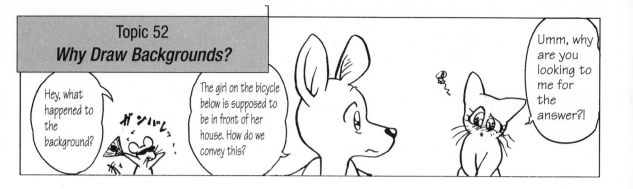

Hey, what happened to the background?

The girl on the bicycle below is supposed to be in front of her house. How do we convey this?

Umm, why are you looking to me for the answer?!

Looking and understanding are manga basics. If possible, avoid explaining the setting with text and convey your messages with visuals. As a general rule, try to use one frame on each page to express the setting.

• Backgrounds are an important method of expression. Rely on dialogue and explanations for things that don't make good visuals.

Background Management

By changing the tones used on the same drawing, it is possible to express different times of day, seasons and weather conditions.

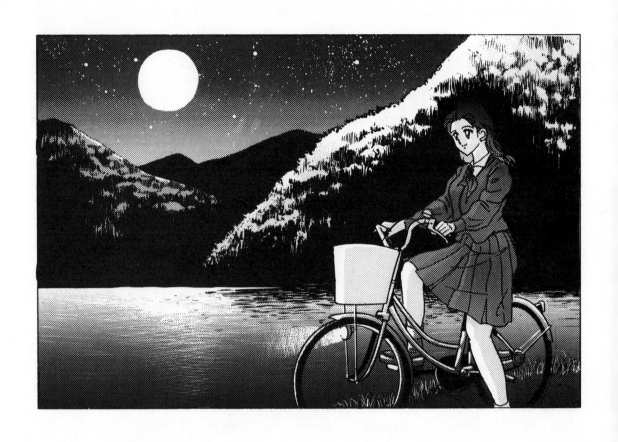

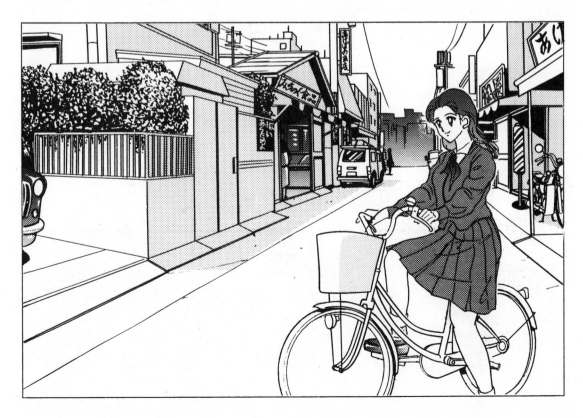

Topic 53
Drawing Backgrounds – Part 1

You need nothing more than a pen and a ruler—and your imagination, of course—to draw great-looking buildings.

The main character in front of her school.

The main character in front of her school with some hills in the background.

It is essential that you prepare and study reference materials as you draw.

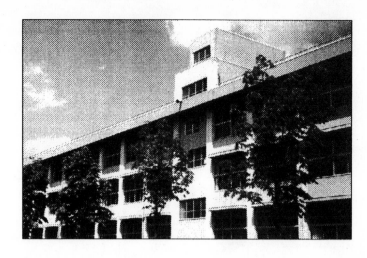

The areas are often measured, especially when drawing things from the front.

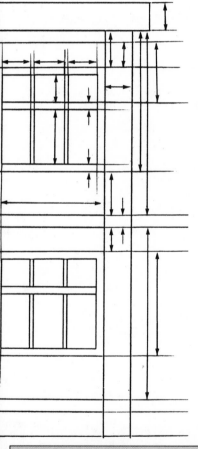

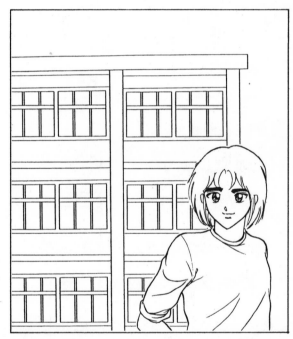

Carefully line up and draw the width and spaces between the windows in schools and other structures.

Carefully line up:
- size of windows
- height of each floor
- space between windows and overhangs
- space between windows of poles
- things to be careful of

Special attention needs to be made to:
- vertical lines of buildings (perpendicular lines from the ground up)

- The height of the building usually is drawn with straight perpendicular lines. If the lines become slanted, the building appears to be leaning.

Pay close attention to the balance and spacing between windows. If you want to make the background look simple, omit or shorten some of the lines.

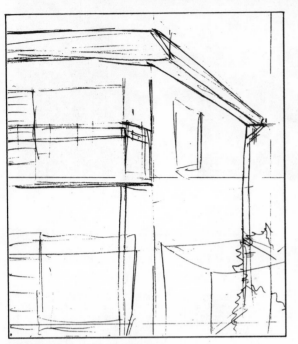

`1` Make a rough sketch.

ruler

`2` Tighten up the sketch.
(Use a ruler to draw horizontal and vertical lines.)

`3` Ink in the drawing.

scrap paper

manga page

Most artists find it easiest to rotate the paper as they draw. Doing so allows you to remain in a comfortable position while continuing to draw smooth, straight lines in all directions.

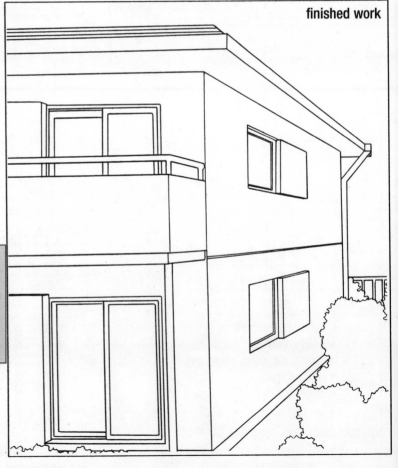

finished work

Drawing Backgrounds – Part 2
Depth Lines

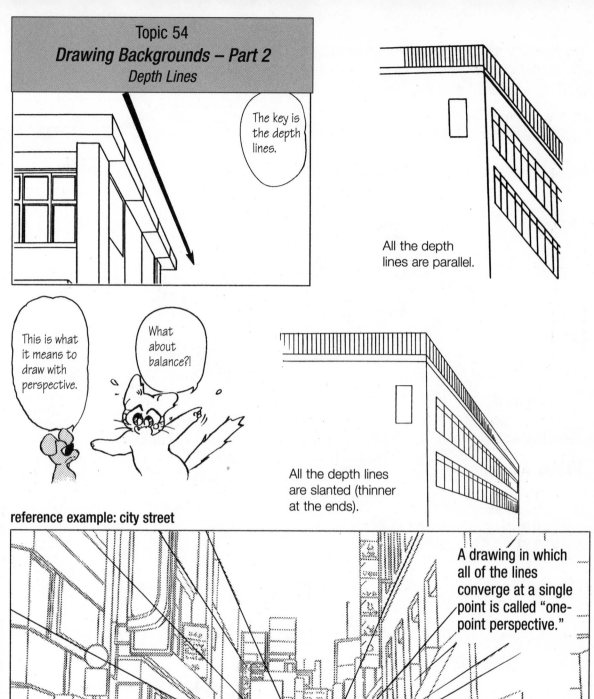

The key is the depth lines.

All the depth lines are parallel.

This is what it means to draw with perspective.

What about balance?!

All the depth lines are slanted (thinner at the ends).

reference example: city street

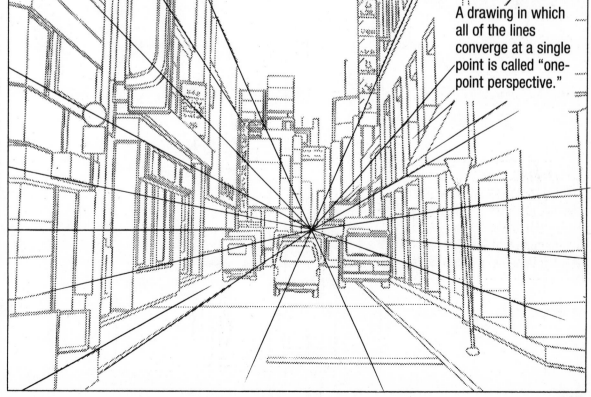

A drawing in which all of the lines converge at a single point is called "one-point perspective."

Two-Point and Three-Point Perspective

When you want to show the depth of
buildings, draw slanted lines.

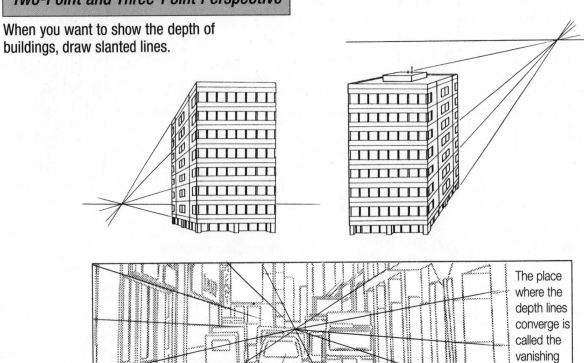

The place
where the
depth lines
converge is
called the
vanishing
point.

A drawing whose lines converge in two
vanishing points is called "two-point
perspective." This is the technique most
often used in manga.

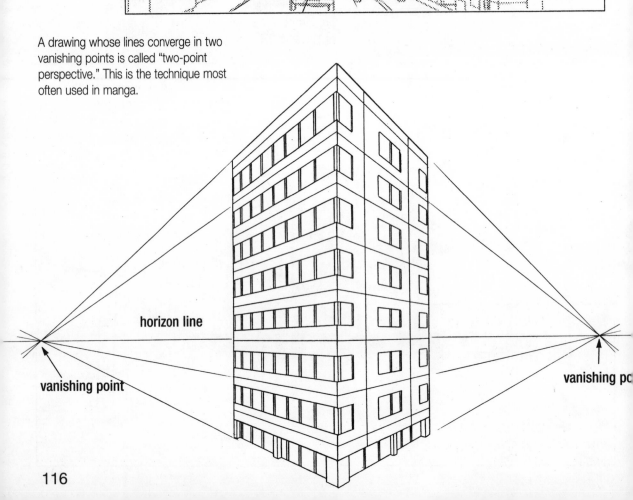

horizon line

vanishing point

vanishing po

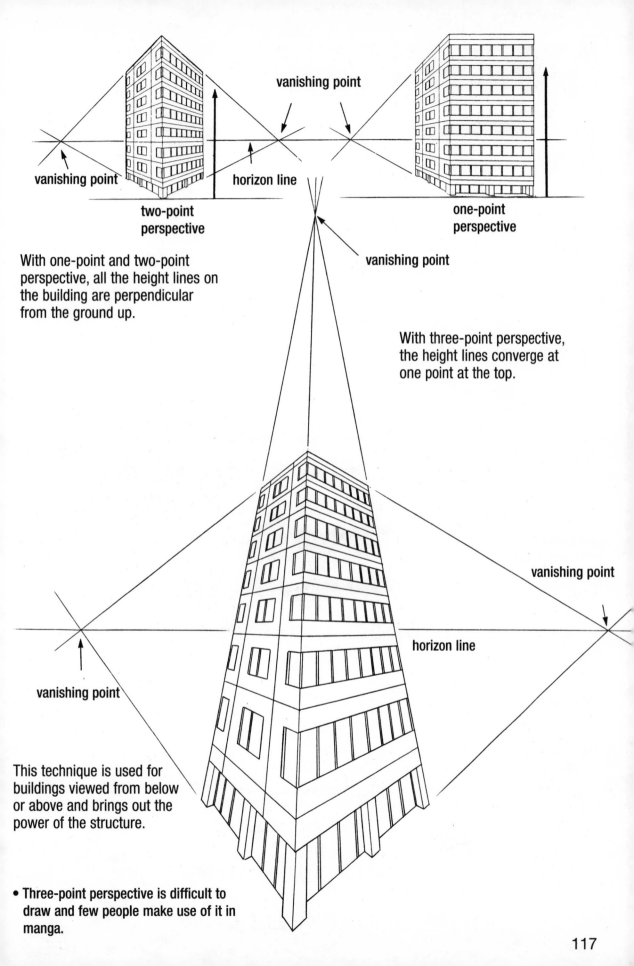

vanishing point

two-point
perspective

vanishing point

horizon line

vanishing point

one-point
perspective

With one-point and two-point
perspective, all the height lines on
the building are perpendicular
from the ground up.

vanishing point

With three-point perspective,
the height lines converge at
one point at the top.

vanishing point

horizon line

vanishing point

This technique is used for
buildings viewed from below
or above and brings out the
power of the structure.

• Three-point perspective is difficult to
 draw and few people make use of it in
 manga.

Topic 56
One-Point Perspective Principles – Part 1
Horizon Lines

For your background, first draw a line along the horizon.

For example, from this angle…

These are called horizon lines. This is a technique that involves drawing a horizontal line.

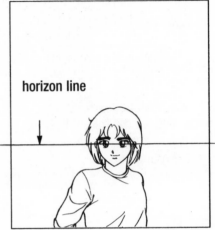

horizon line

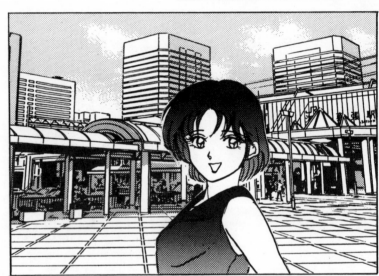

When viewed from a horizon line, the camera takes a picture like this.

Pay close attention to this line.

eye height

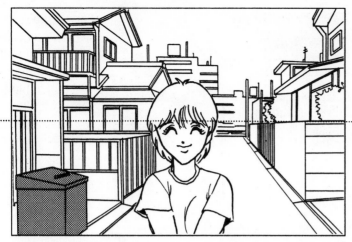

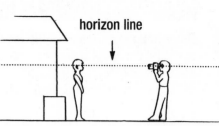

horizon line

If this horizon line is close to the center of the frame, objects above and below can be seen quite well.

Lie on your stomach and look up.

The "eye line" is not your line of vision, as the eyes are able to move left, right, up and down. Rather, eye line refers to the horizon line, and the two terms are used interchangeably. The eye line is determined by distance between the person's eyes (or the lens of a camera) and the ground.

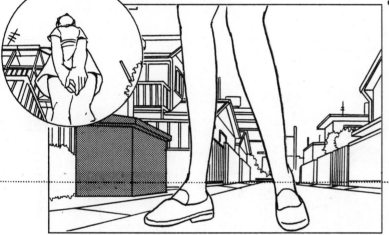

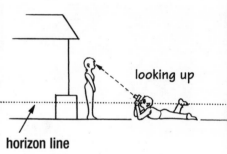

looking up

horizon line

Before, the upper area could be seen but now it cannot.

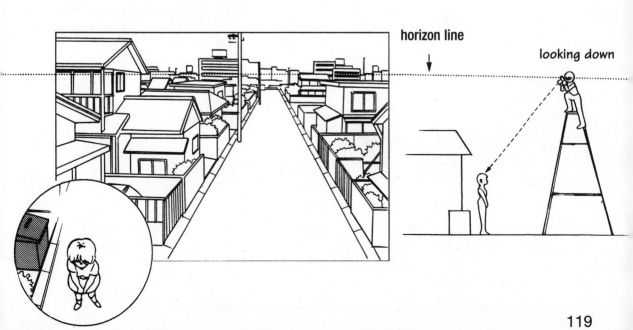

horizon line

looking down

Determining the height of the horizon line is the same as choosing a camera angle. And selecting the vanishing point is the same as choosing the focal point when composing a photograph.

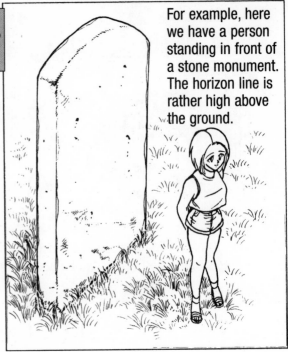

For example, here we have a person standing in front of a stone monument. The horizon line is rather high above the ground.

Photo taken standing in a normal position from the front.

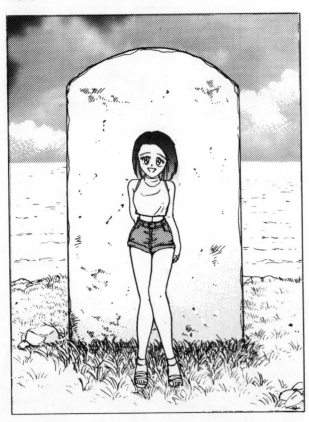

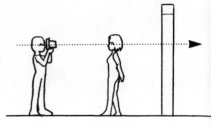

viewed from the side

The horizon line in this example is the normal height of the person holding the camera. Standing in front of the model and taking a photograph renders a picture like this.

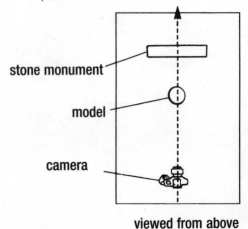

viewed from above

• Although this picture is viewed from straight ahead, it is also possible to represent the same model from a bird's-eye view ("fukan" in Japanese) or an angle from the ground up ("aori" in Japanese).

Holding the camera at the same height, try moving to either side and taking a picture. Now the thickness of the stone monument can be seen.

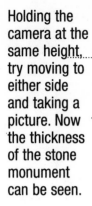

side view

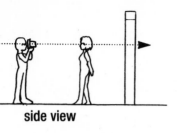

stone monument

model

camera

viewed from above
(movement to either side
of the front)

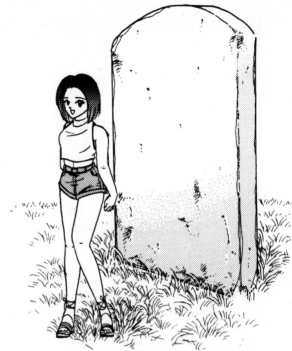

Photo taken standing slightly to the side.

The vanishing point is the position where the person is looking from or where the camera is shooting.

So, the vanishing point is very important!

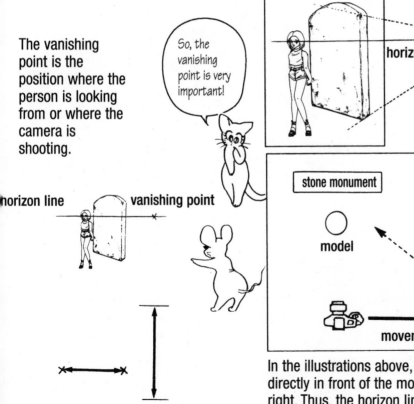

A 2

horizon line

horizon line **vanishing point**

stone monument

model

line of vision

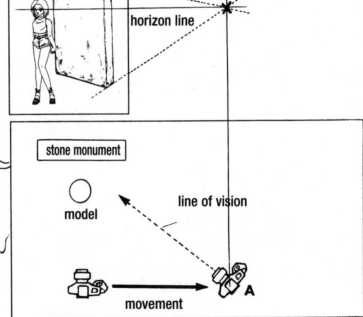

movement

A

In the illustrations above, the camera moves from a position directly in front of the model to a position farther to the right. Thus, the horizon line remains the same, but the vanishing point changes.

When you want depth lines like this, place the horizon line in the face or chest area.

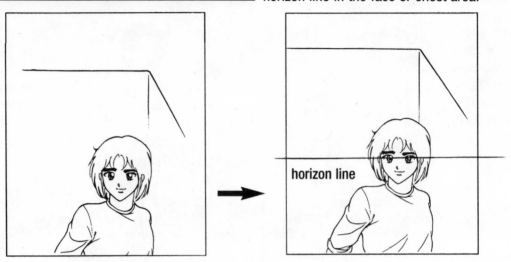

horizon line

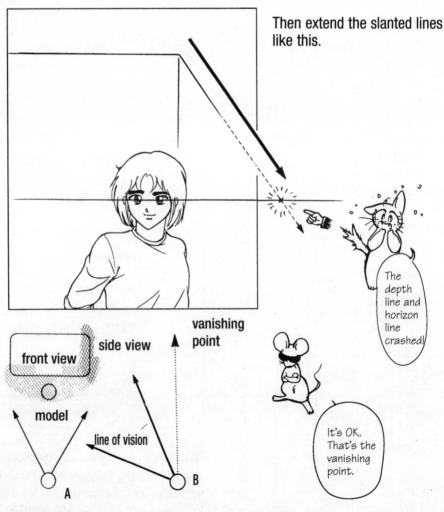

Then extend the slanted lines like this.

The depth line and horizon line crashed!

It's OK. That's the vanishing point.

vanishing point

side view

front view

model

line of vision

A

B

• Position the horizon line along the face or chest. This is just like composing a photograph.

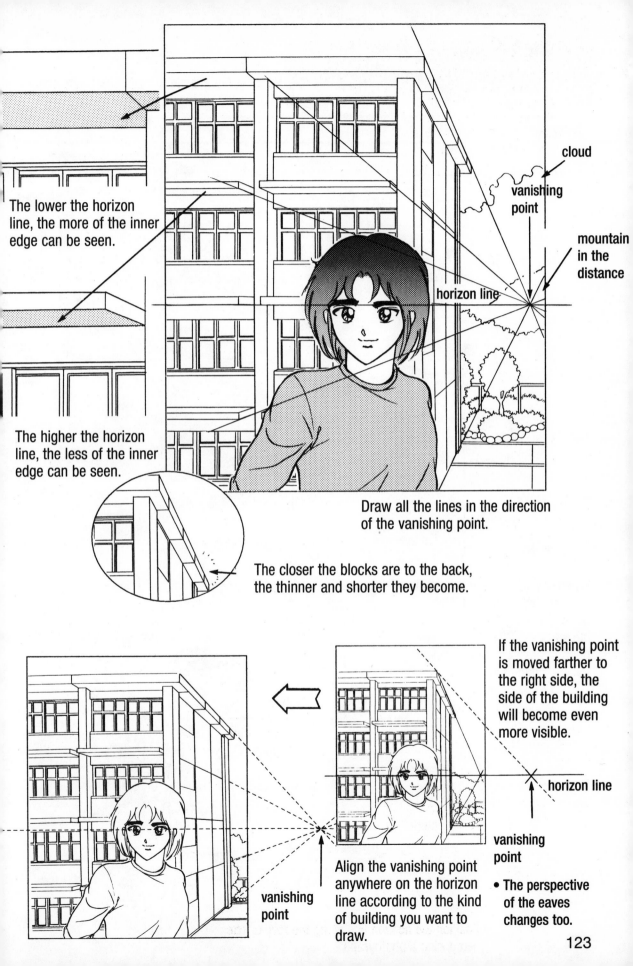

The lower the horizon line, the more of the inner edge can be seen.

cloud

vanishing point

mountain in the distance

horizon line

The higher the horizon line, the less of the inner edge can be seen.

Draw all the lines in the direction of the vanishing point.

The closer the blocks are to the back, the thinner and shorter they become.

If the vanishing point is moved farther to the right side, the side of the building will become even more visible.

horizon line

vanishing point

• The perspective of the eaves changes too.

Align the vanishing point anywhere on the horizon line according to the kind of building you want to draw.

vanishing point

123

Topic 59
One-Point Perspective Principles – Part 4
Supplement

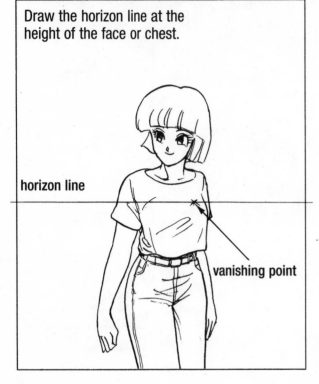

Draw the horizon line at the height of the face or chest.

horizon line

vanishing point

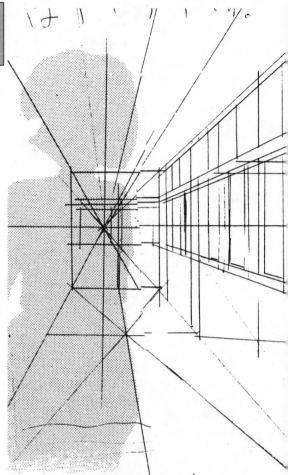

Fix a vanishing point somewhere on the horizon line. When depth lines are drawn in the direction of the vanishing point, it is easy to draw the background. This kind of one-point perspective is well-suited for drawing indoor scenes.

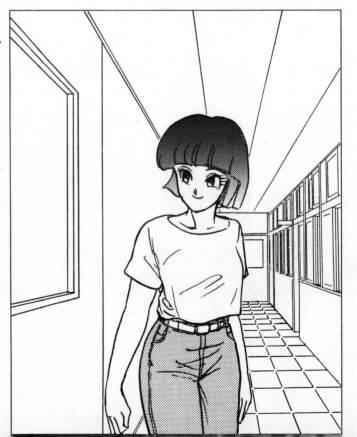

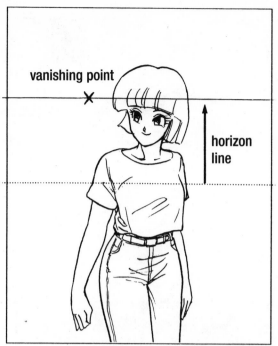

vanishing point

horizon line

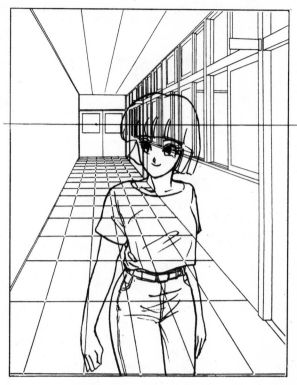

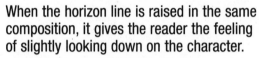

When the horizon line is raised in the same composition, it gives the reader the feeling of slightly looking down on the character.

If it does not look strange to your eyes, there is no need to worry about it. However, when drawing backgrounds, you always have to consider where the scene is being shot from—the position of the character and the background—as you draw.

Topic 60
What's Next?

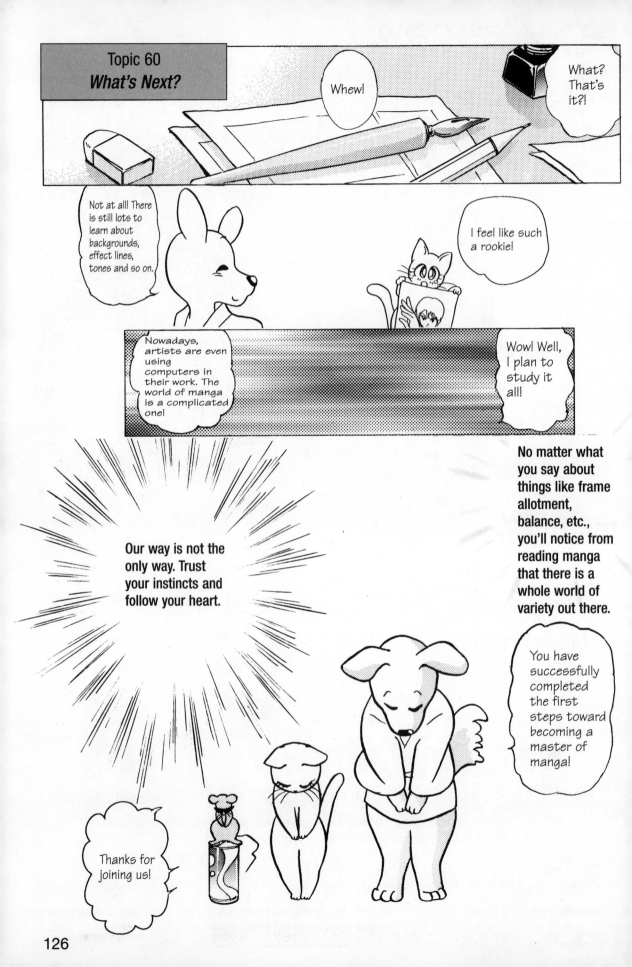

Whew!

What? That's it?!

Not at all! There is still lots to learn about backgrounds, effect lines, tones and so on.

I feel like such a rookie!

Nowadays, artists are even using computers in their work. The world of manga is a complicated one!

Wow! Well, I plan to study it all!

No matter what you say about things like frame allotment, balance, etc., you'll notice from reading manga that there is a whole world of variety out there.

Our way is not the only way. Trust your instincts and follow your heart.

You have successfully completed the first steps toward becoming a master of manga!

Thanks for joining us!